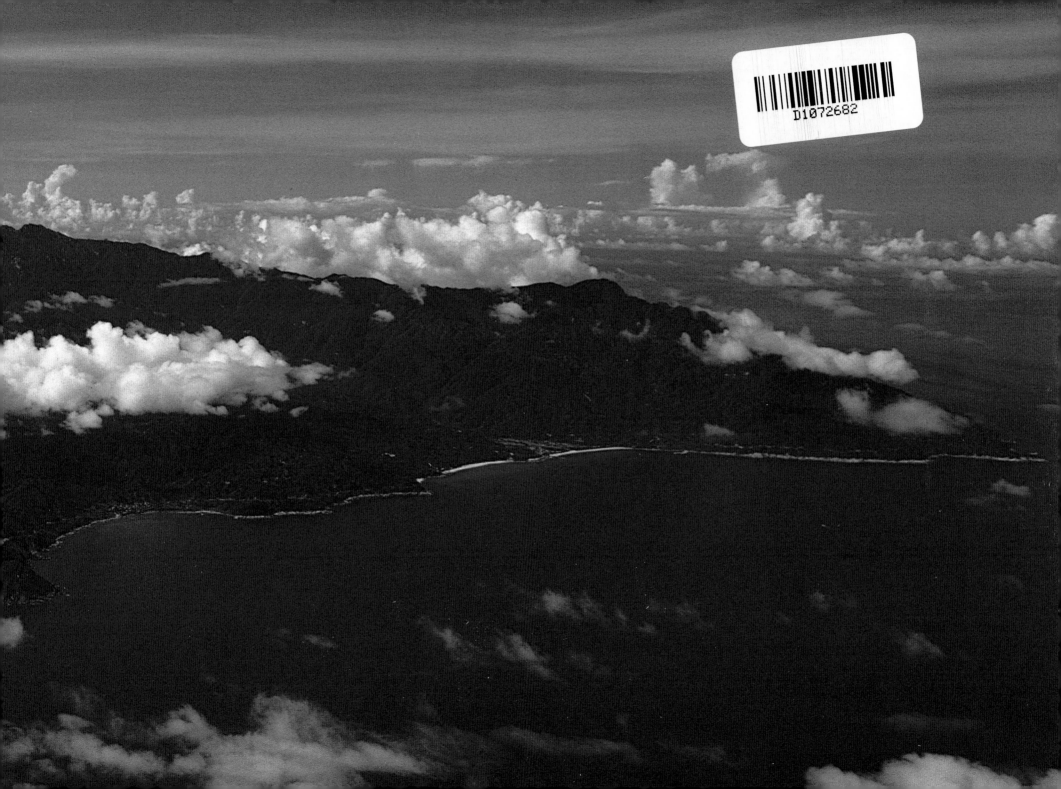

ANCIENT GRACE

Inside the Cedar Sanctuary of Yakushima Island

HIROAKI YAMASHITA

First English Edition, 1992
10 9 8 7 6 5 4 3 2 1

Executive Editor: Seiji Horibuchi
Managing Editor: Satoru Fujii
Translation: Frederik L. Schodt
Book Design: Shinji Horibuchi
Publisher: Masahiro Oga

Library of Congress Cataloging-in-Publication Data
Yamashita, Hiroaki, 1955-
[Kiyo!. English]
Ancient grace : inside the cedar sanctuary of Yakushima Island /
Hiroaki Yamashita ; introduction by Sansei Yamao.
 p. cm.
Translation of: Kiyo!
ISBN 0-929279-79-4 : $34.95
1. Cryptomeria japonica—Japan—Yaku Island—Pictorial works.
2. Forest ecology—Japan—Yaku Island—Pictorial works.
3. Yaku Island (Japan)—Pictorial works. I. Title.
QK494.5.T3Y3613 1992
585'.2—dc20 91-47131
 CIP

Originally published in 1992 as *Kiyo!* by Shogakukan, Inc., Tokyo, Japan

Editors: Hiroshi Yasumura and Shuji Shimamoto
Art Director: Shinji Horibuchi

In collaboration with **Canon**

Cadence Books
A Division of Viz Communications, Inc.
P.O. Box 77010
San Francisco, California 94107

Printed in Japan

The Forest as Self

Sansei Yamao

Yakushima is an island with truly extraordinary forests.

Nearly round, with a circumference of only sixty miles, Yakushima is crammed with forty-six individual peaks over three thousand feet high and twenty over five thousand feet. In fact, the seven tallest mountains in the entire Kyushu region (including the tallest, Mt. Miyanoura) are all on Yakushima. The climate on the coast is subtropical, with an average year-round temperature of sixty-eight degrees, but high in the mountains the average is only around forty-five degrees—nearly the same as that of central Hokkaido, Japan's northernmost island. As a result, Yakushima is blessed with a rich variety of forests unique to each of its regions—the coast, the foothills, the mountains, and the highest peaks.

Ancient Grace, Hiroaki Yamashita's book of photographs, focuses on the mountain and peak regions of Yakushima, where the Yakushima islanders themselves rarely go. His book is, in effect, a "self-portrait," for he has spent many years here, discovering and expressing himself through his photographs. And it is no ordinary area. The islanders have long referred to it with special reverence as the "far peaks," and they imbue these words with yearning, relief, mystery, and, finally, an ever-so-subtle sense of the "sacred" (and in this context, I mean "Life itself").

Unlike Yamashita, I have lived for the past fifteen years in the island's foothills. I occasionally visit the far peaks, but only three or four days a year at the most. At this rate I could spend the rest of my life on the island and never approach Yamashita's wealth of experience.

Where I live, the native forests consist mostly of broadleaf evergreen trees, mainly oak and chinquapin. Much of the area has been transformed into cedar tree plantations, but true forests still remain here and there. A large mountain stream flows in front of my house, and trees cover both sides of the valley. Bands of monkeys make appearances throughout the day, and even as I now write in the autumn, I can hear the cries of deer echoing throughout the valley. It is certainly not as silent here as in the far peaks region, but the sound of the stream creates a calm that is never broken.

Forests may be the best of all things, because in forests we can find ourselves; we can discover our best "self-portraits." In their totality, forests provide us both a place to return to and a place to go. As such they are a source of profound consolation and peace. And the individual trees that make up the forests also provide us with a calm joy, for they, too, are a type of self-portrait, illuminating and unraveling the mysteries of life.

The ancient Indian work of philosophy, *The Upanishads*, is one of my favorite books and self-portraits. In the Chandogya Upanishad, said to be the oldest portion of the text, written seven centuries before Christ, are these words:

Strike at the root of a tree; it would bleed / But still live. Strike at the trunk; it would bleed
But still live. Strike again at the top; / It would bleed but still live. The Self as life
Supports the tree, which stands firm and enjoys / The nourishment it receives.
If the Self leaves one branch, that branch withers. / If it leaves a second, that too withers.
If it leaves a third, that again withers. / Let it leave the whole tree, the whole tree dies.
Just so, dear one, when death comes and the Self / Departs from the body, the body dies.
*But the Self dies not.**

*From *The Upanishads,* translated by Eknath Easwaran (Petaluma, Calif.: Nilgiri Press, 1987).

This passage describes the concept of Atman, in which the essence of Self is viewed as Eternal Life. But we can also learn the same thing directly from the forest. From each individual tree, blade of grass, and bit of moss that we encounter, we receive a deeply reassuring message: although all things that have life must die, Life itself does not die.

I am not referring only to giant trees like the ancient Jomon cedar on Yakushima. Even in the lone *himeshara (Stewartia monadelphi)*, or in the chinquapin that thrive in the foothills, we can see that eternal life and indeed our own life flow. We can see this from the uniquely calm perspective that the trees provide because trees are a calm existence and because the forest they form is an even more profoundly calm existence.

There is a photograph in *Ancient Grace* of a *himeshara* tree in the rain, lashed

by spray. (*See photograph 57.*) The water is silently, slowly being driven around the smooth bark of the tree. Inside the tree, the water is being soaked up; outside the tree, it is falling off in drops. If we look carefully, it is clear that the tree and the water are not separate entities—the tree is but one form of water, and the water is merely standing upright in a form of joy we call a "tree." Hiroaki Yamashita takes a photo at this very instant; I call it poetry.

What can be said of the tree can also be said of a rock. In the photograph of the proud tree standing and cradling a boulder, is not the tree really also a rock? (*See photograph 30.*) The rock and the tree may coexist as different forms of Being, but are they not also embracing each other as brothers who have the same source of Being?

The beginning of the Chandogya Upanishad states:

For as the earth comes from the waters,
plants from earth, and man from plants, so
man is speech, and speech is OM.

When a human sees a profound form of life in a cedar standing erect and embracing a rock, and when he or she sings praises of the tree, are the human, the cedar, and the rock separate existences? I do not believe so. When I look at the forest, I see a deep reflection of my own life. When I'm in the forest, I have a solemn sense of being within my own life. Inside the forest, one tree calls out to me to stop. And what stops me is doubtless that the tree itself is like an old relative of the being called "me."

It is in this sense that I refer to Hiroaki Yamashita's work as a "self-portrait." We look at the world in our daily lives, yet we rarely realize that it is a self-portrait. Unless we are very calm, the world does not appear to us as such. Hiroaki Yamashita is a very calm person. Whether this is his inherent personality or a trait that the forests of Yakushima have given him, I do not know. But I do know that this collection of photographs shows him to possess an extraordinarily rare quality these days, dynamic calmness.

Sansei Yamao is a poet who lives on the island of Yakushima. Like Gary Snyder, whom he considers a good friend, he often writes of his love for nature. He has published numerous collections of his work.

Special Thanks to:
Sansei Yamao
Saburo Nagai
Aiko Nagai
Masaharu Hyodo
Yutaka Suzuki

Chieko Yamamoto
Takeshi Hosokawa
Hiromi Noguchi
Ikuko Yamashita
Yakushima San-Bun-Ken
Q Photo International
Rainbow Society

ANCIENT GRACE
Inside the Cedar Sanctuary of Yakushima Island

HIROAKI YAMASHITA

Cadence Books San Francisco

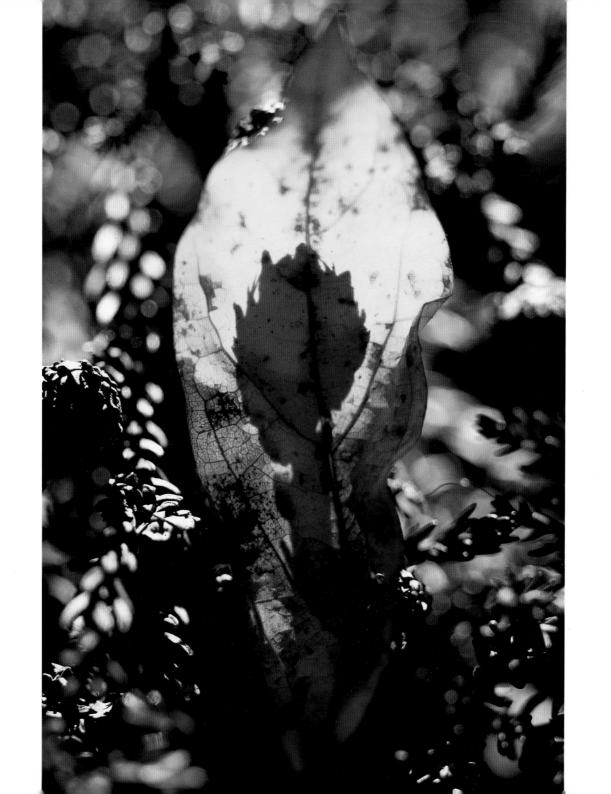

Sweet beckoning of a rare forest—
Enter its inviting hush, listen for its voices…

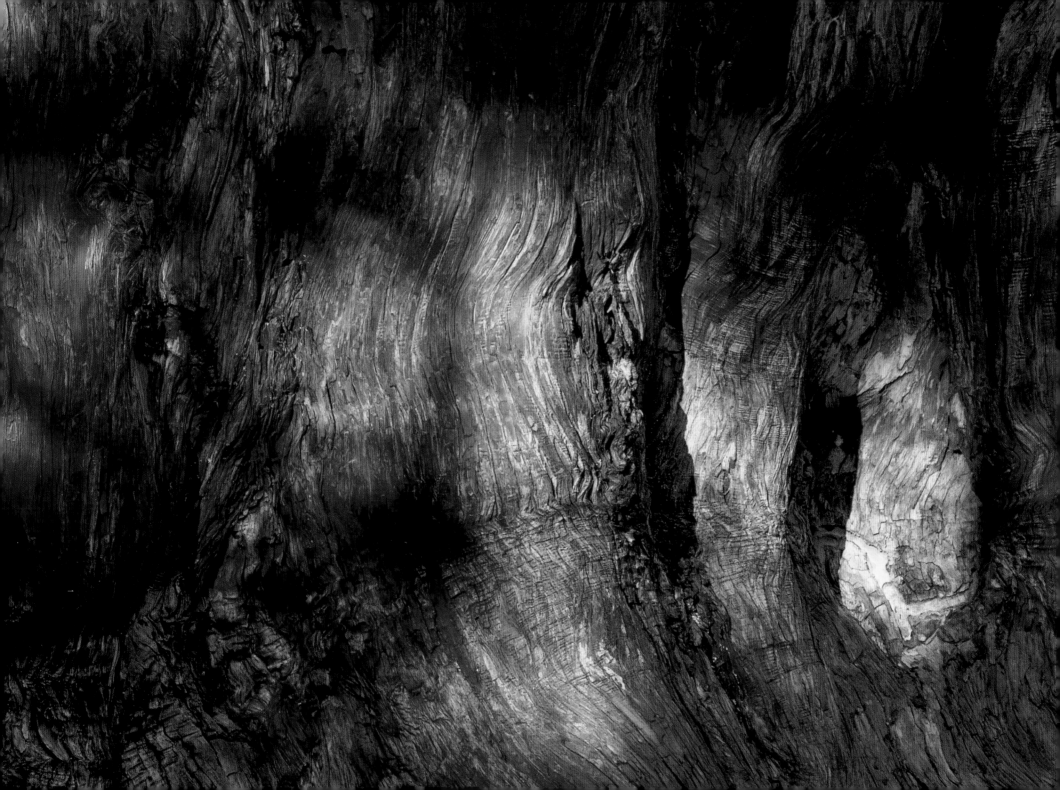

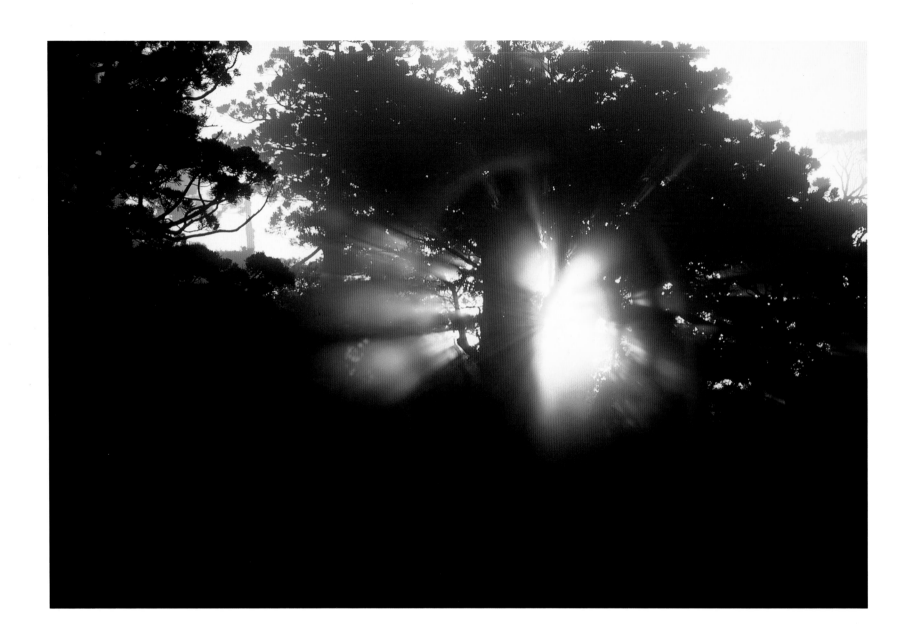

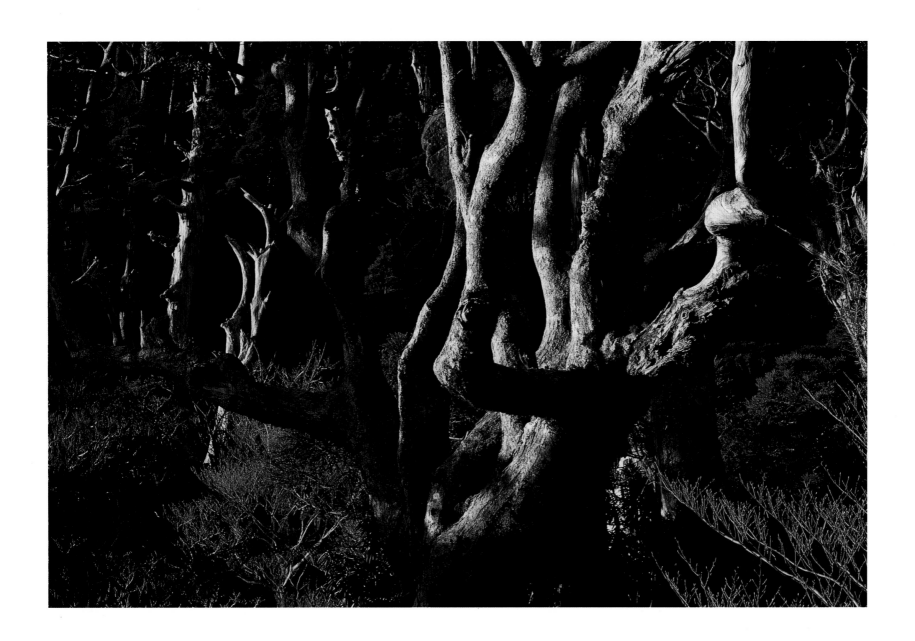

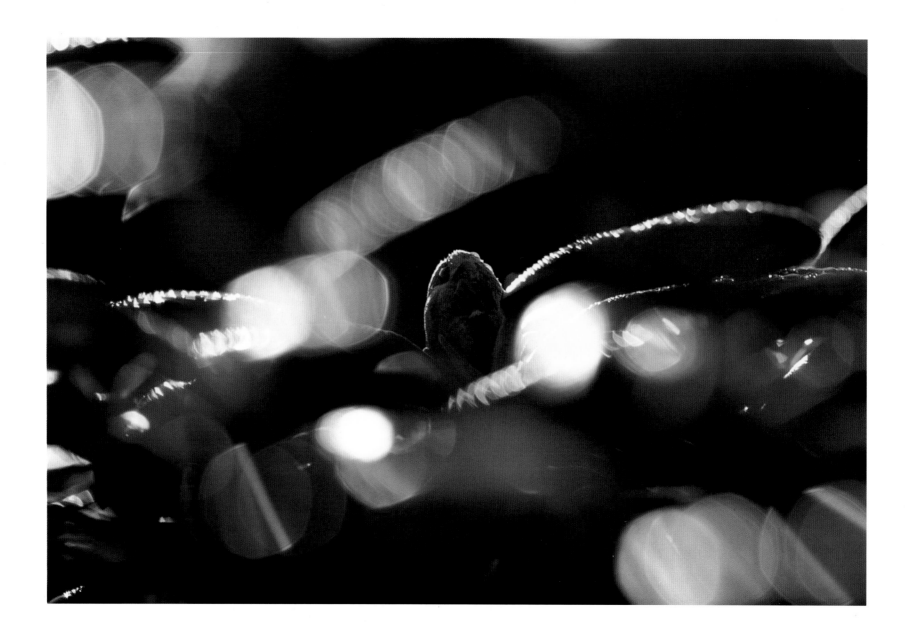

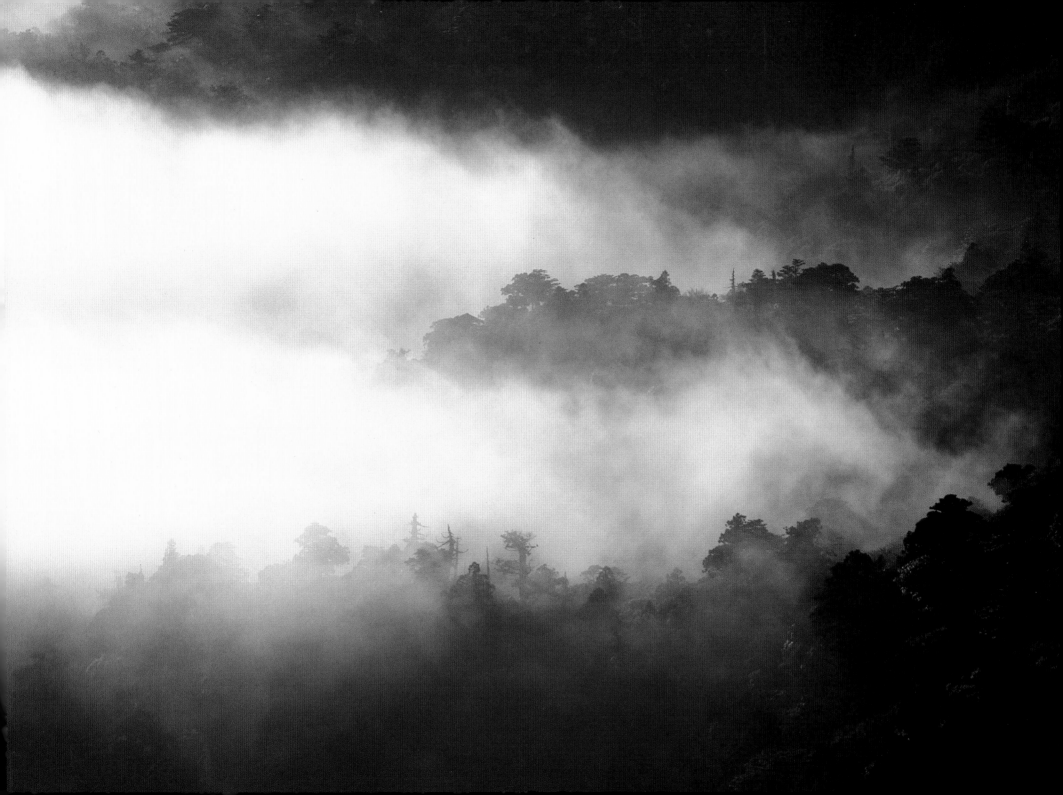

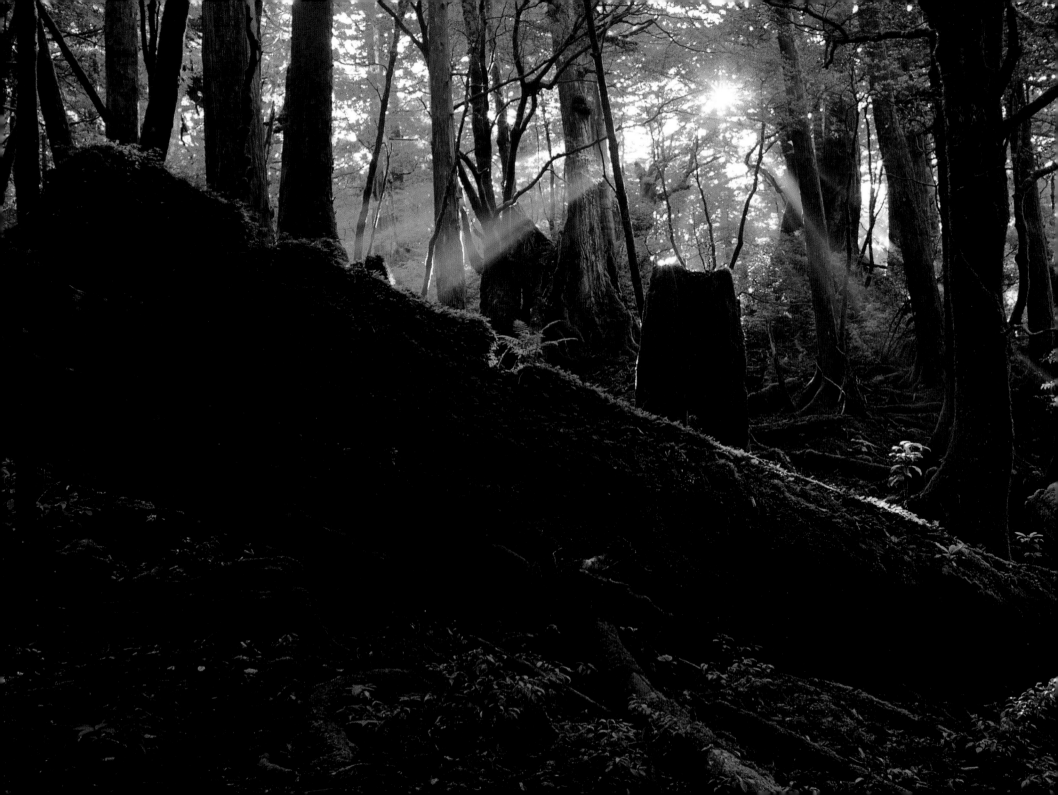

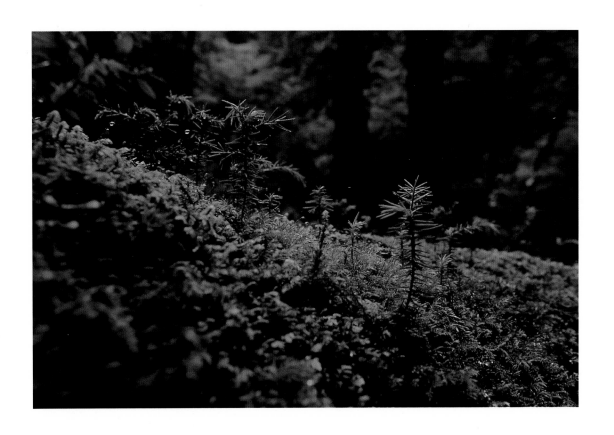

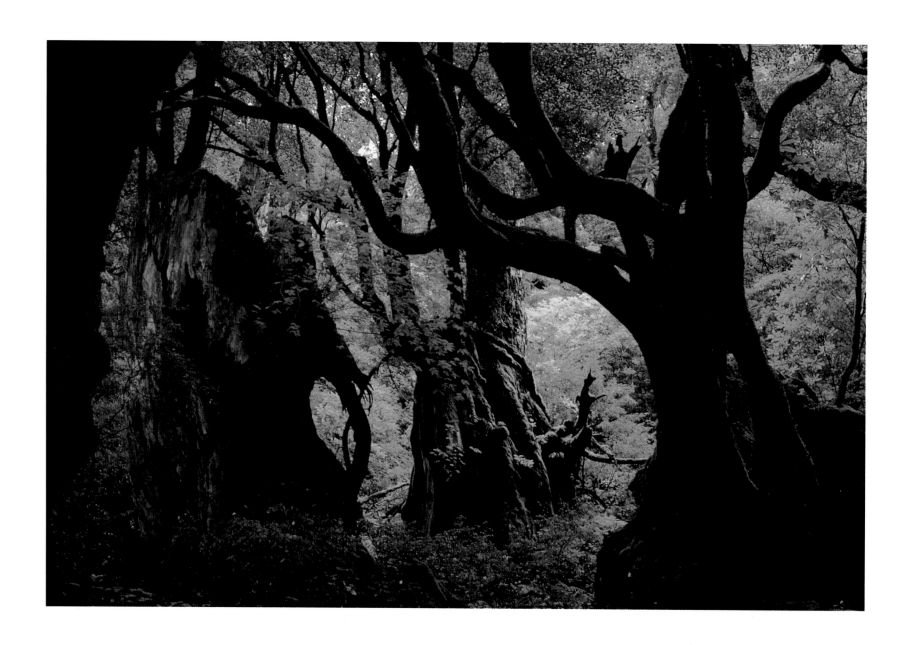

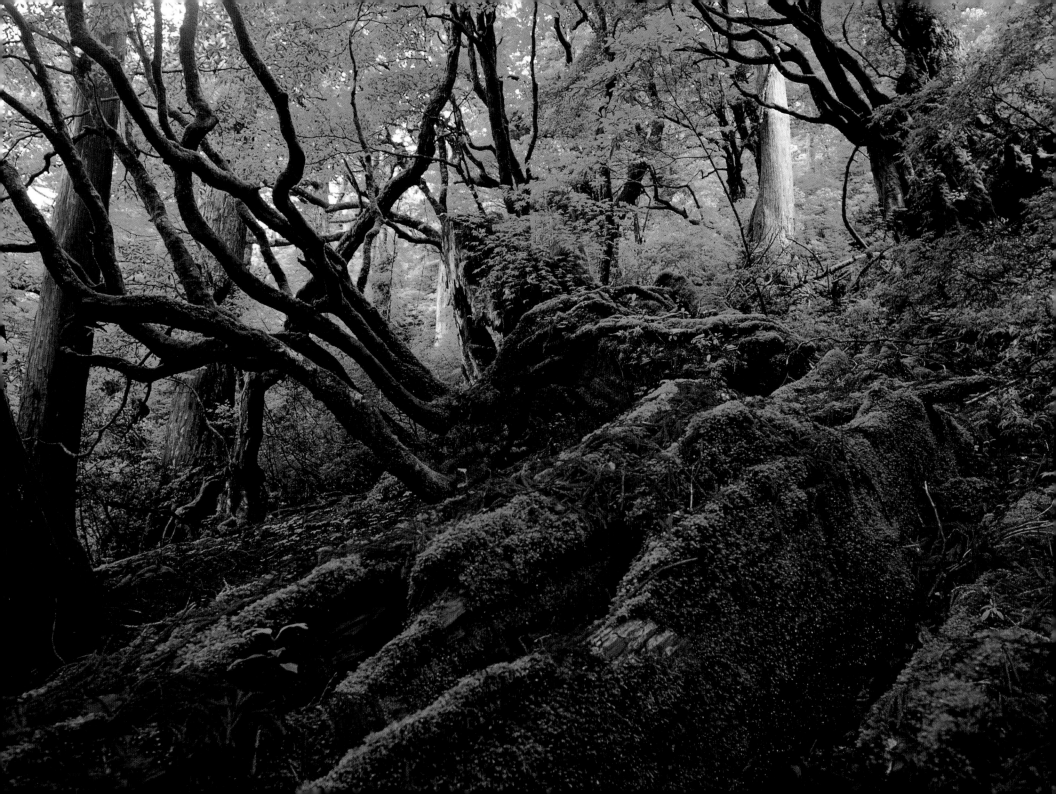

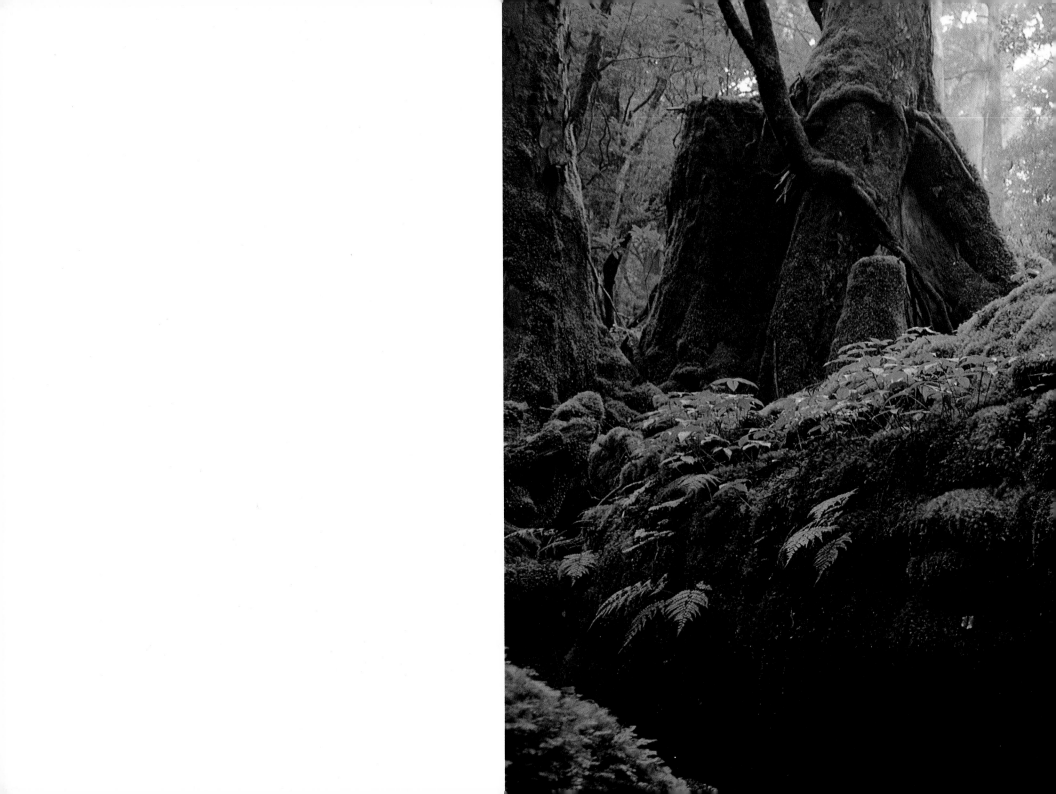

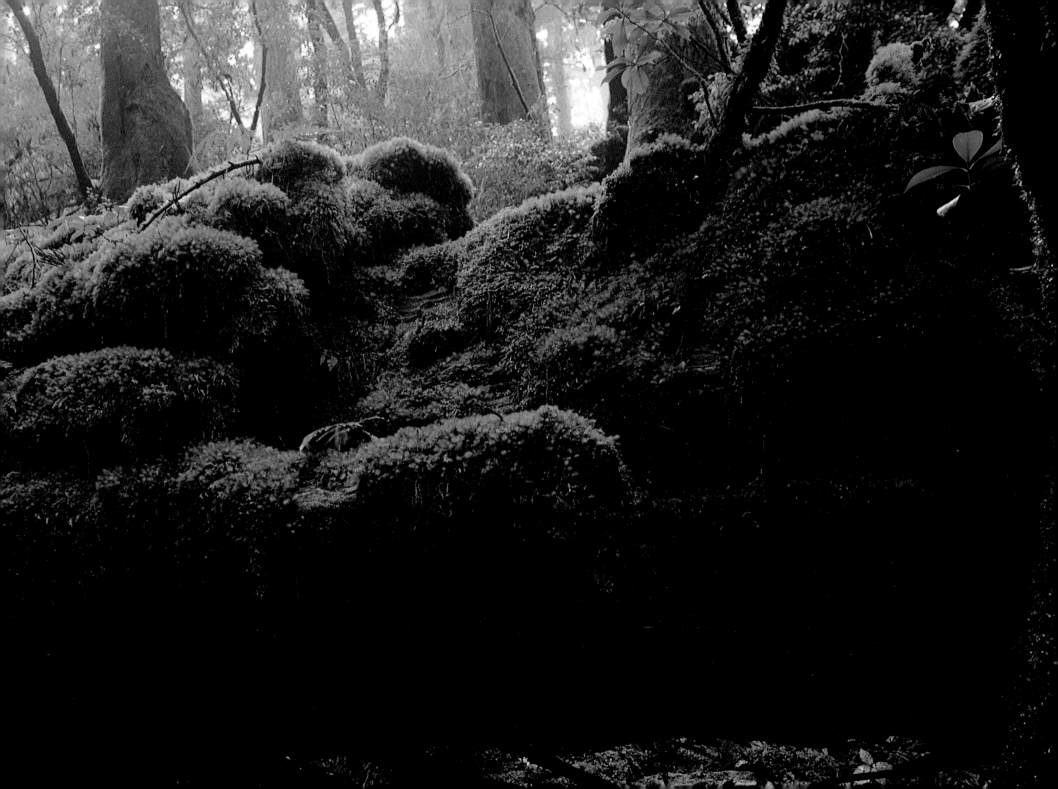

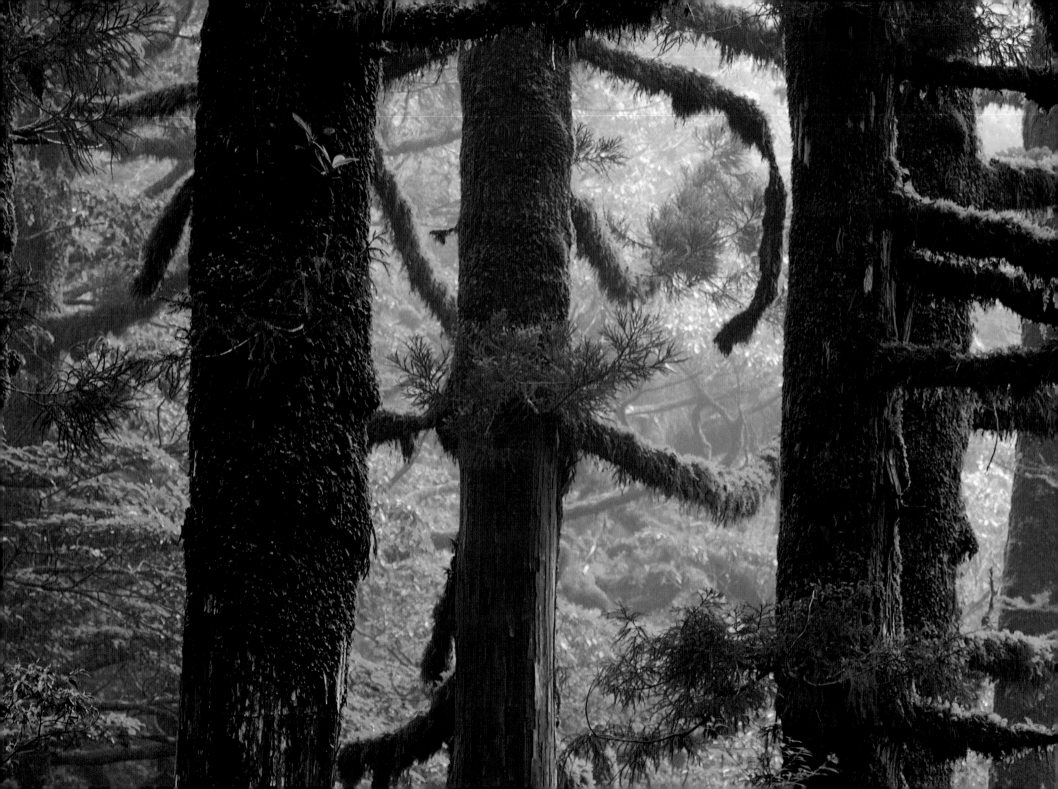

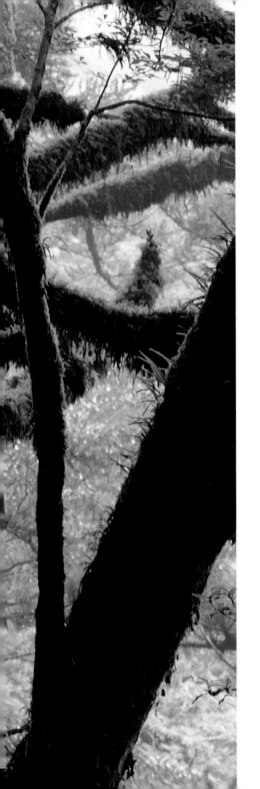
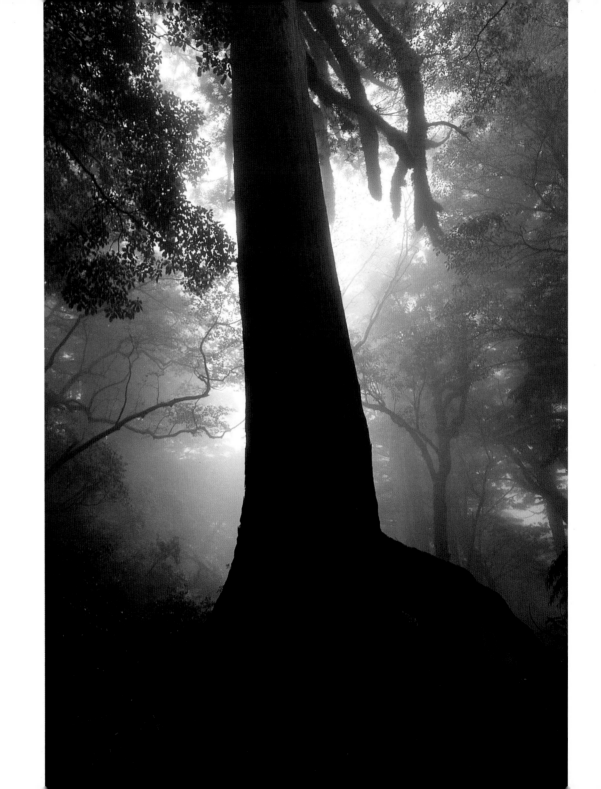

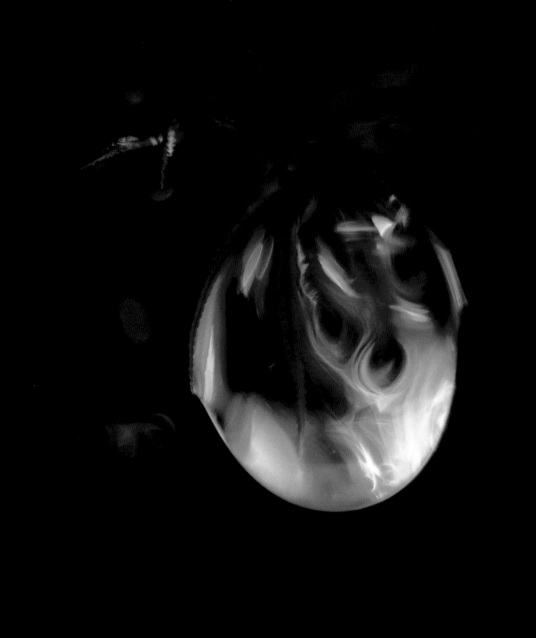

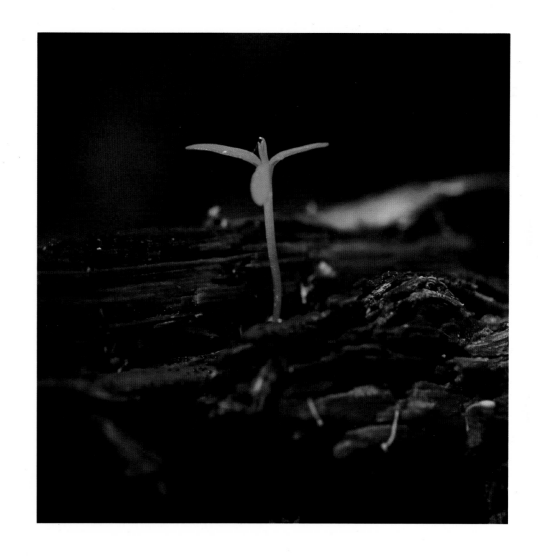

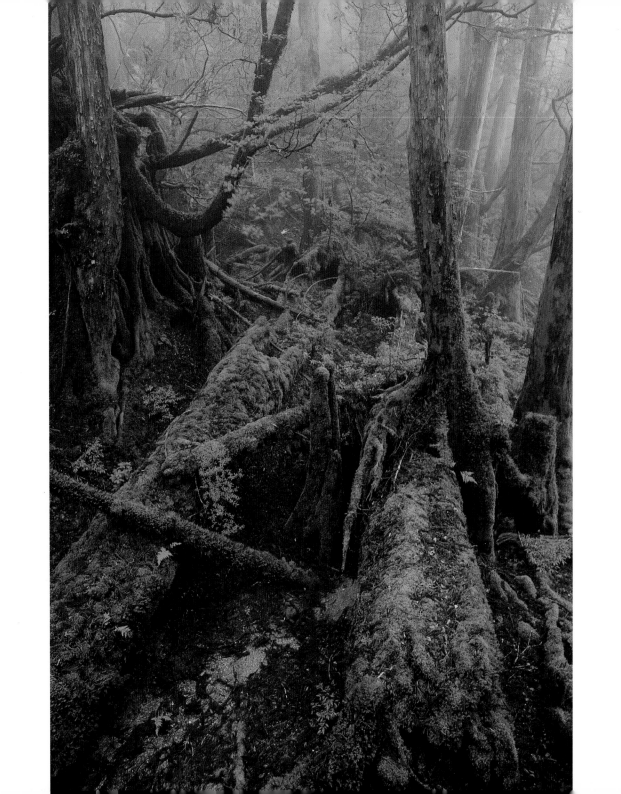

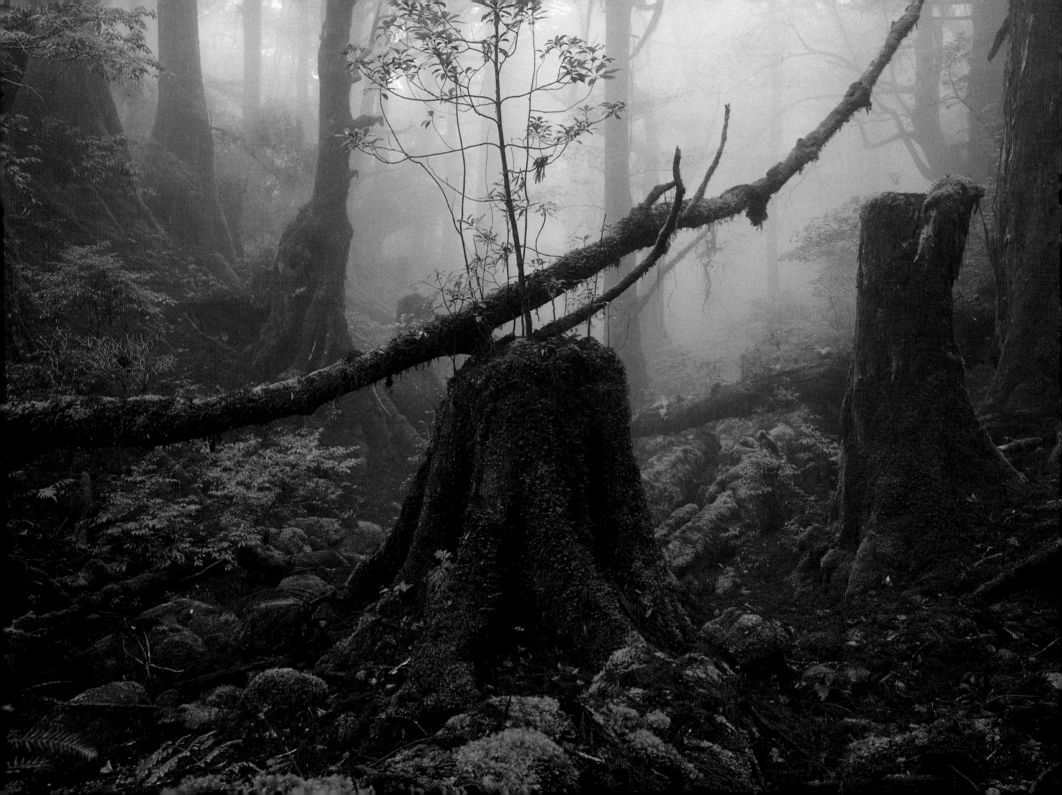

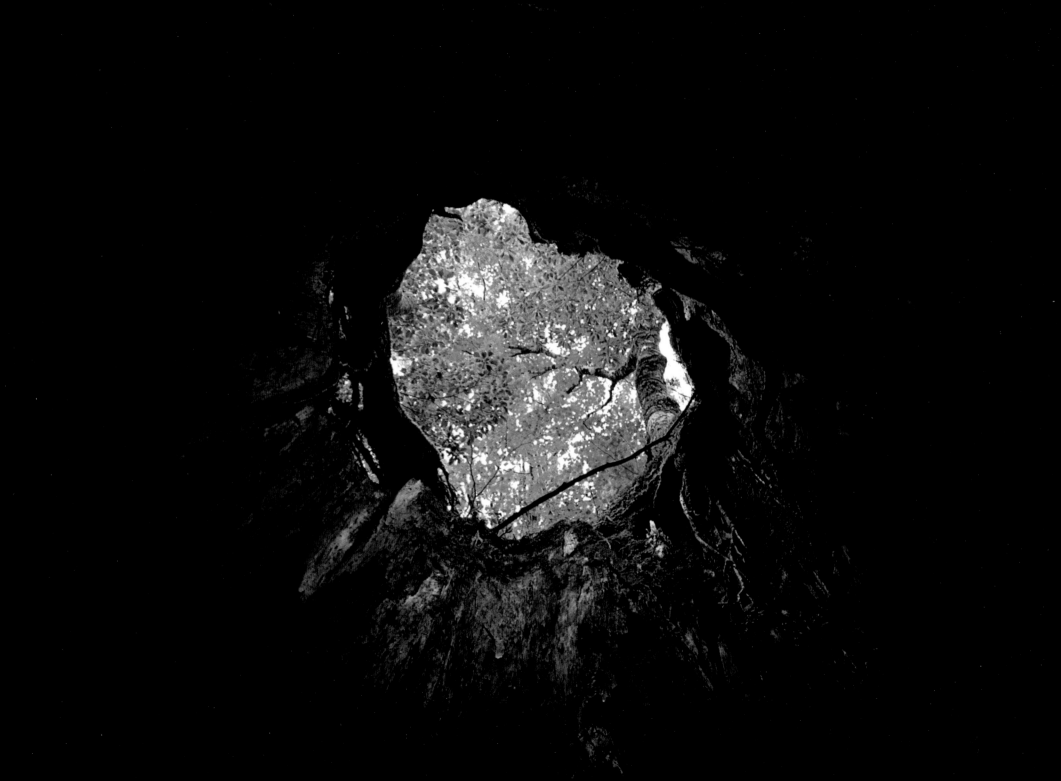

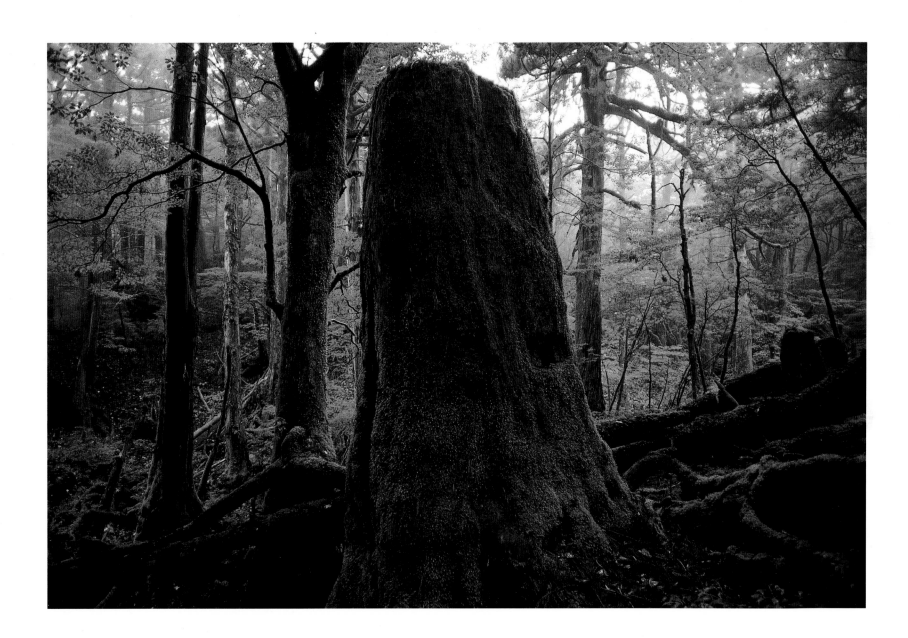

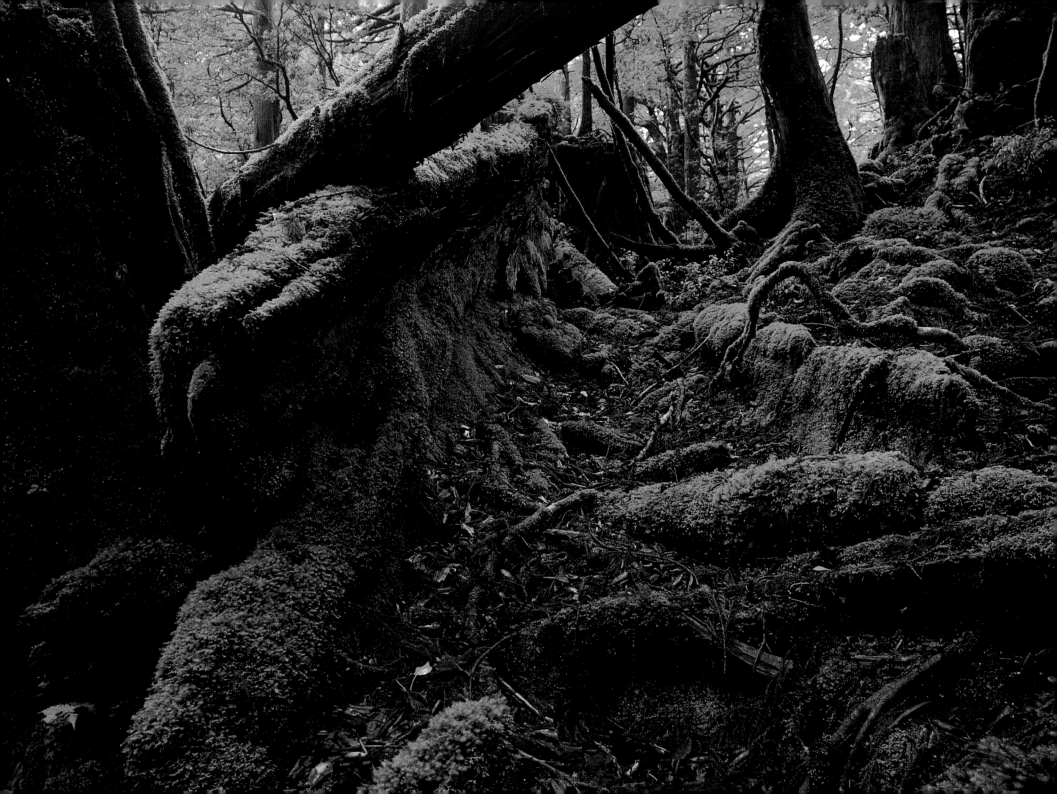

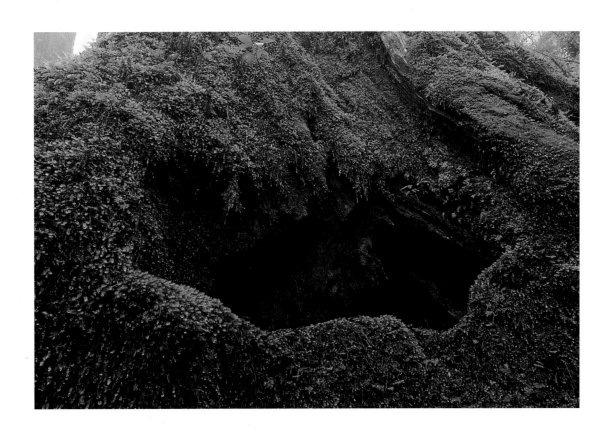

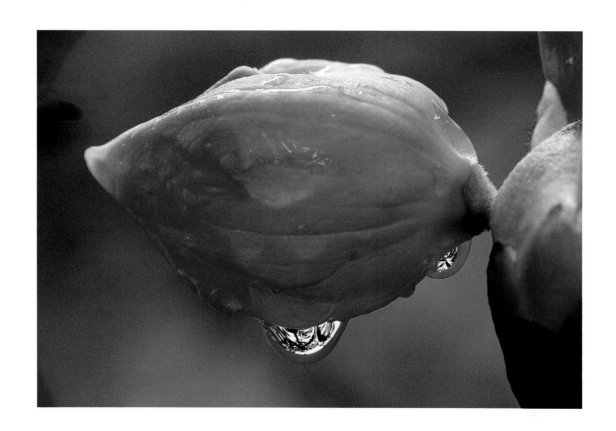

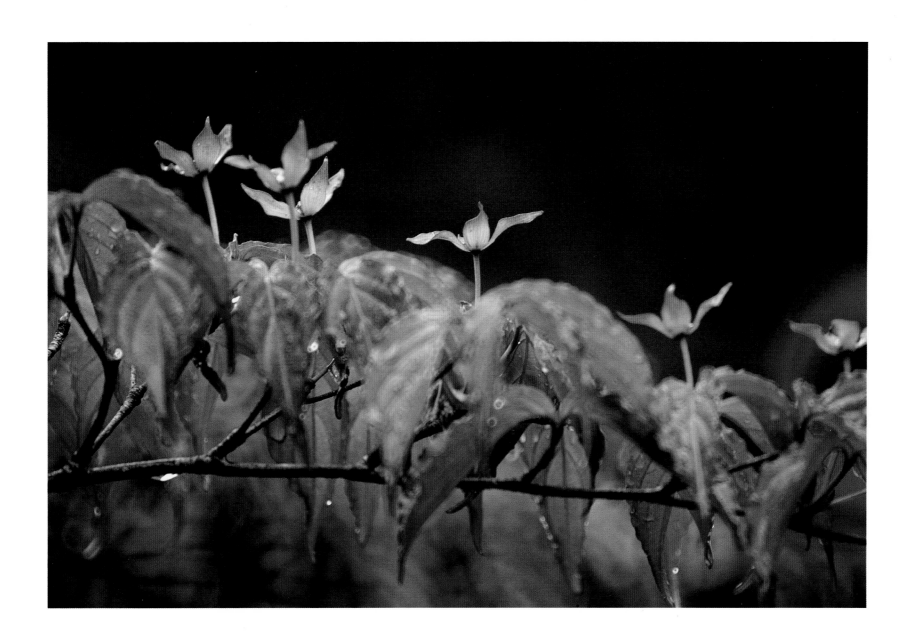

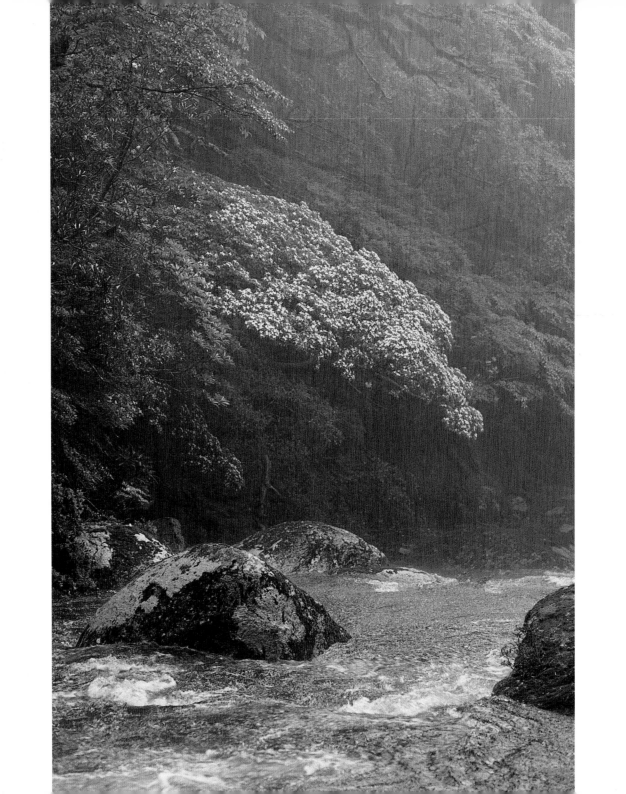

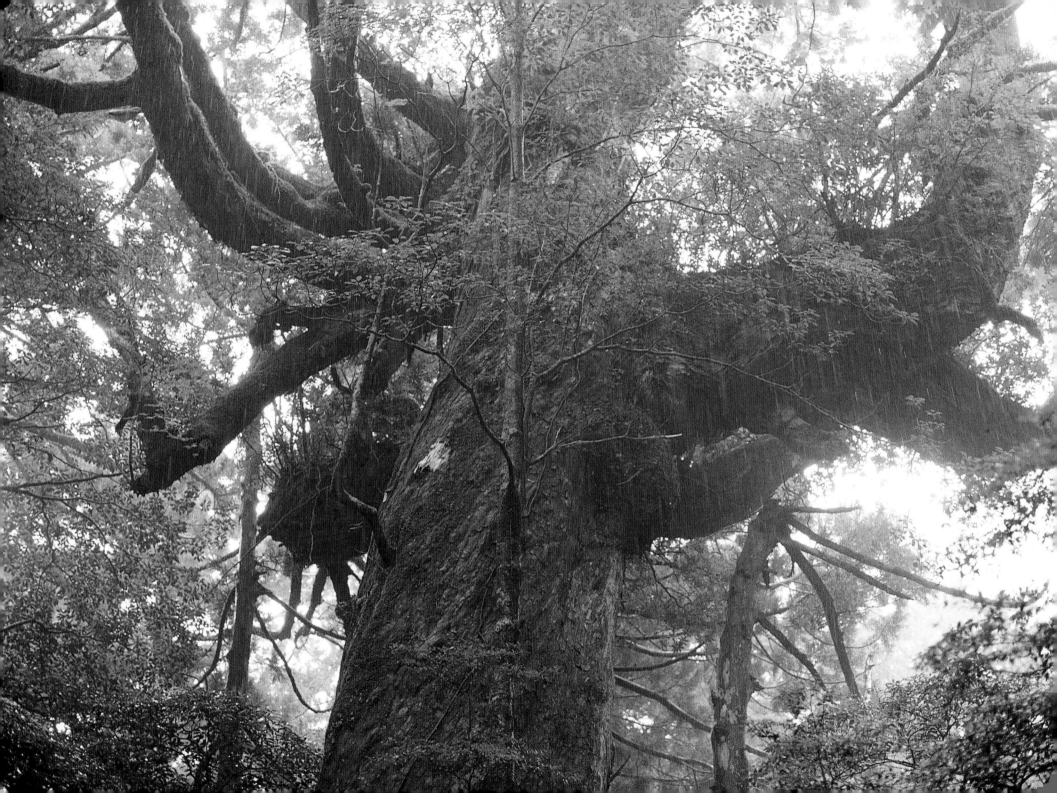

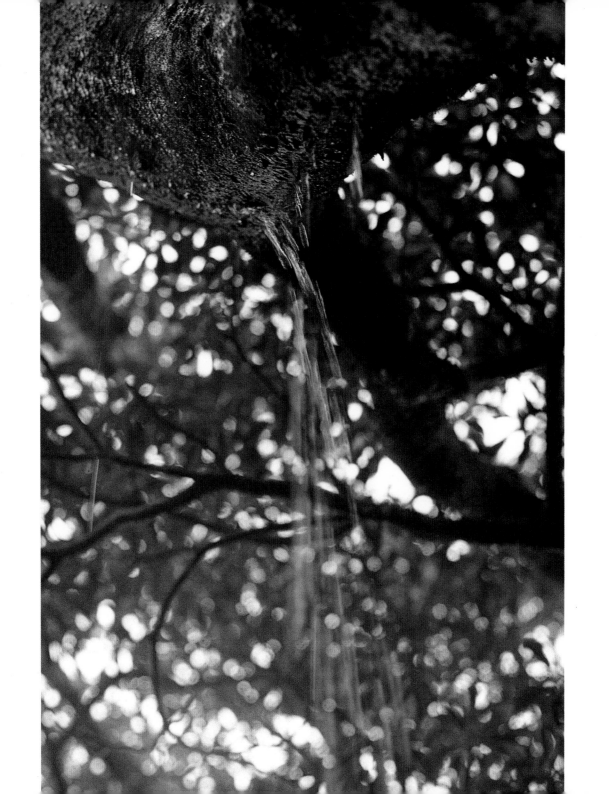

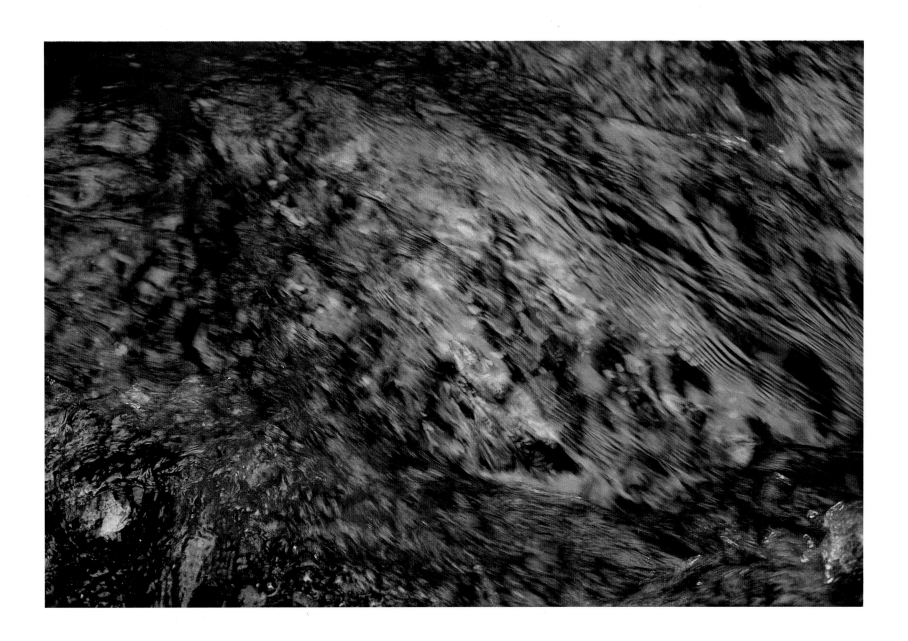

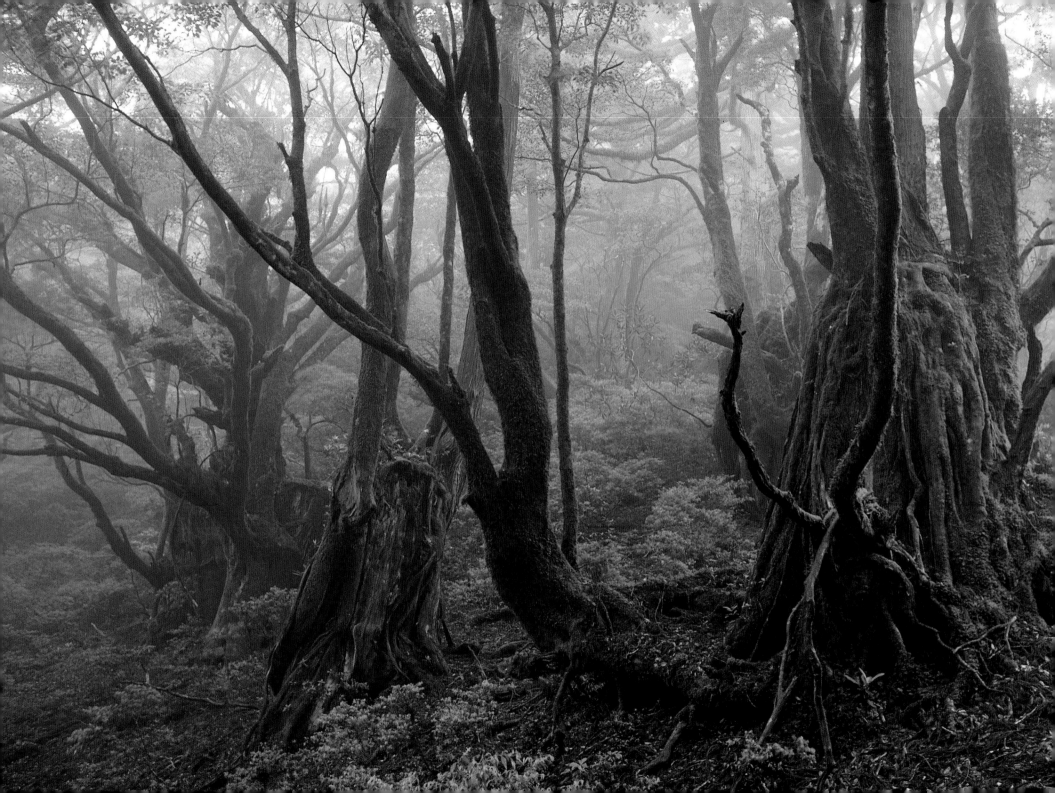

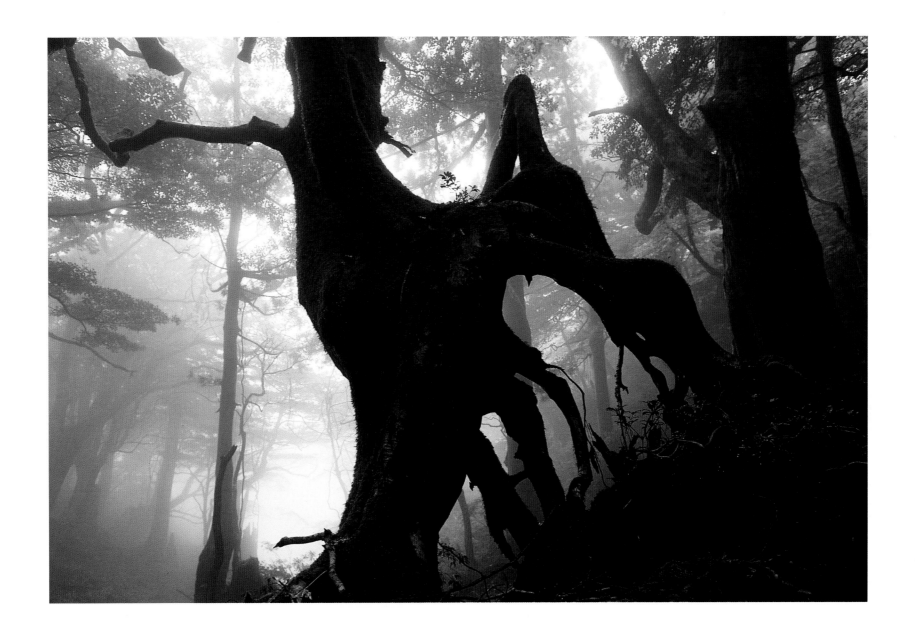

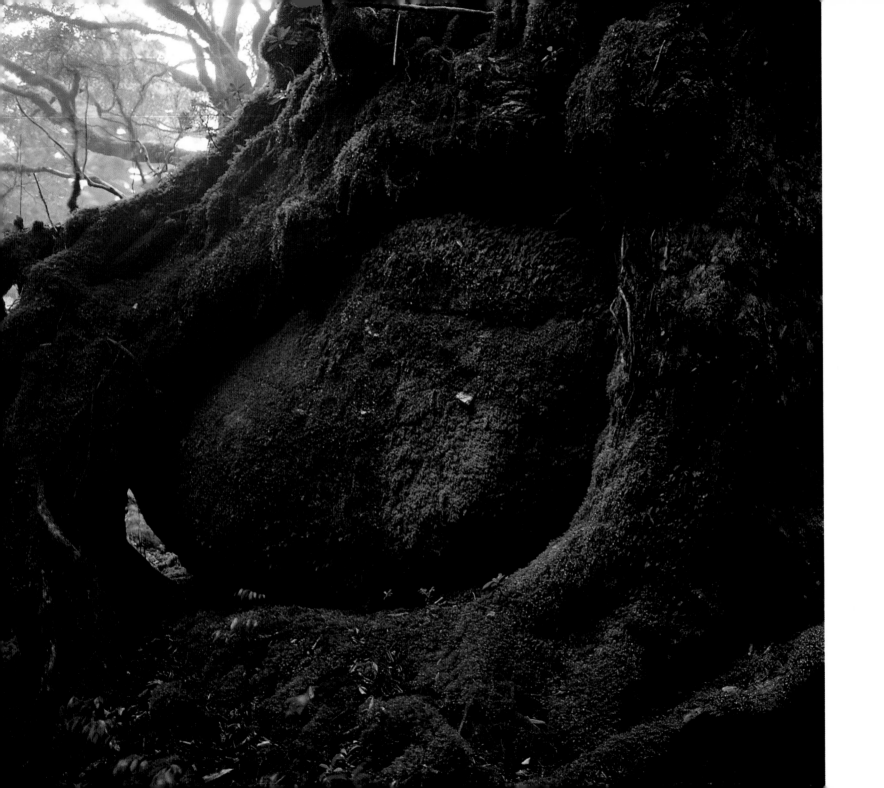

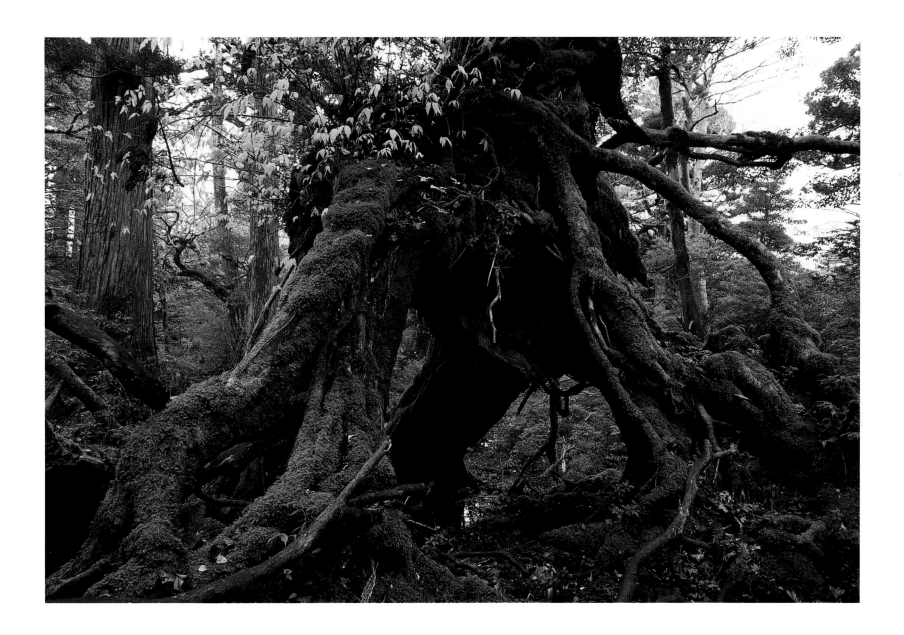

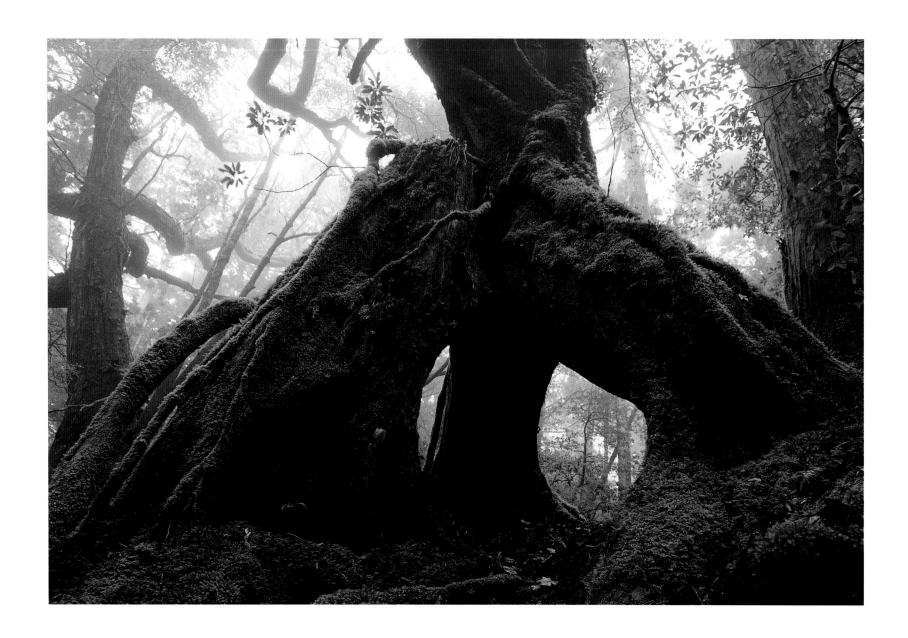

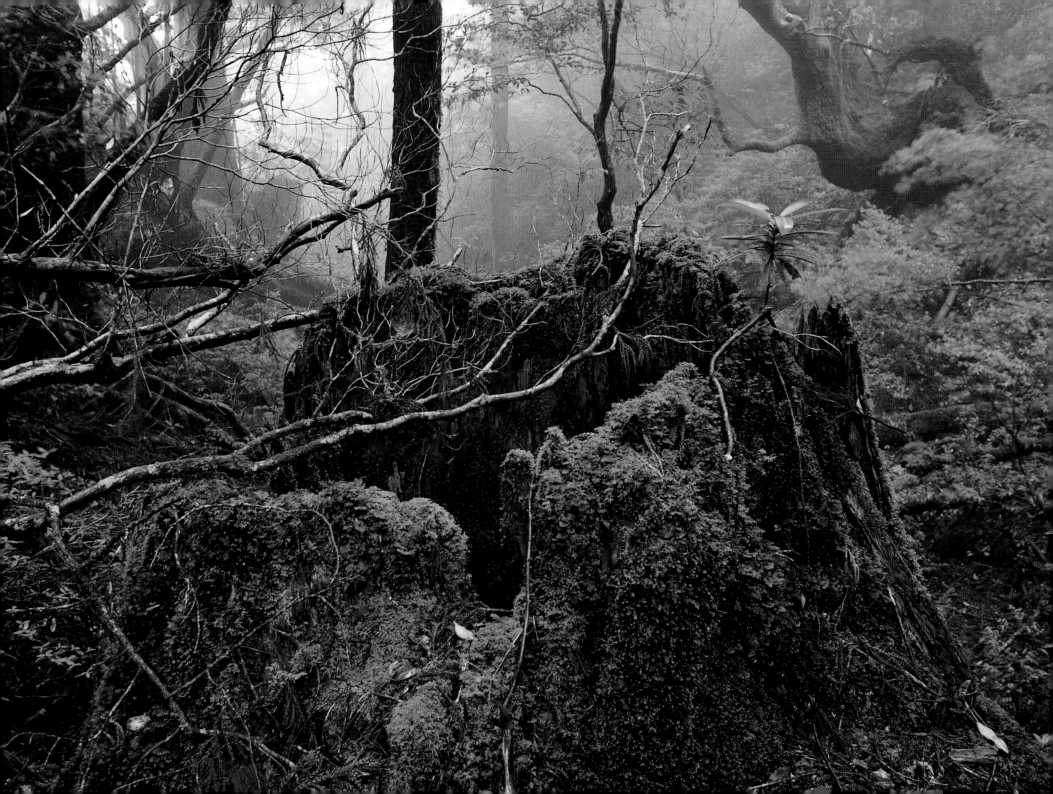

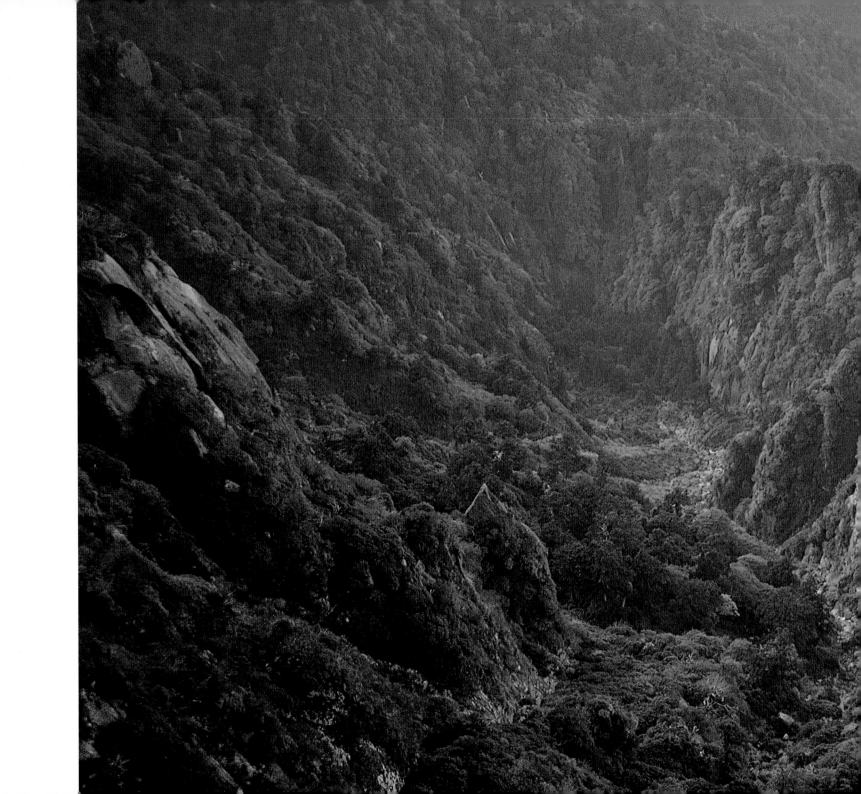

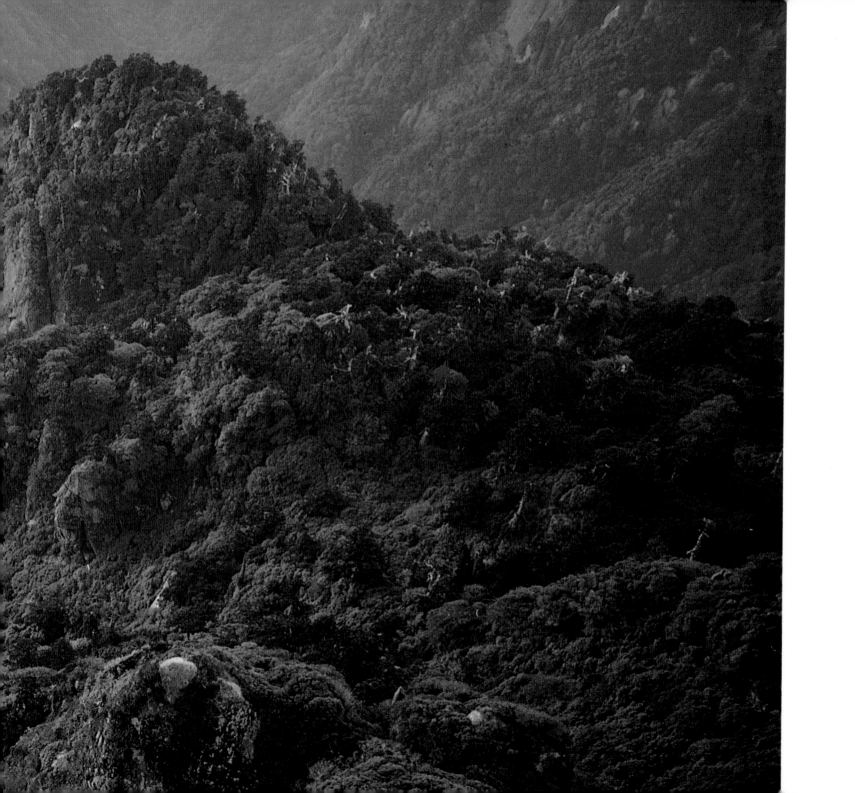

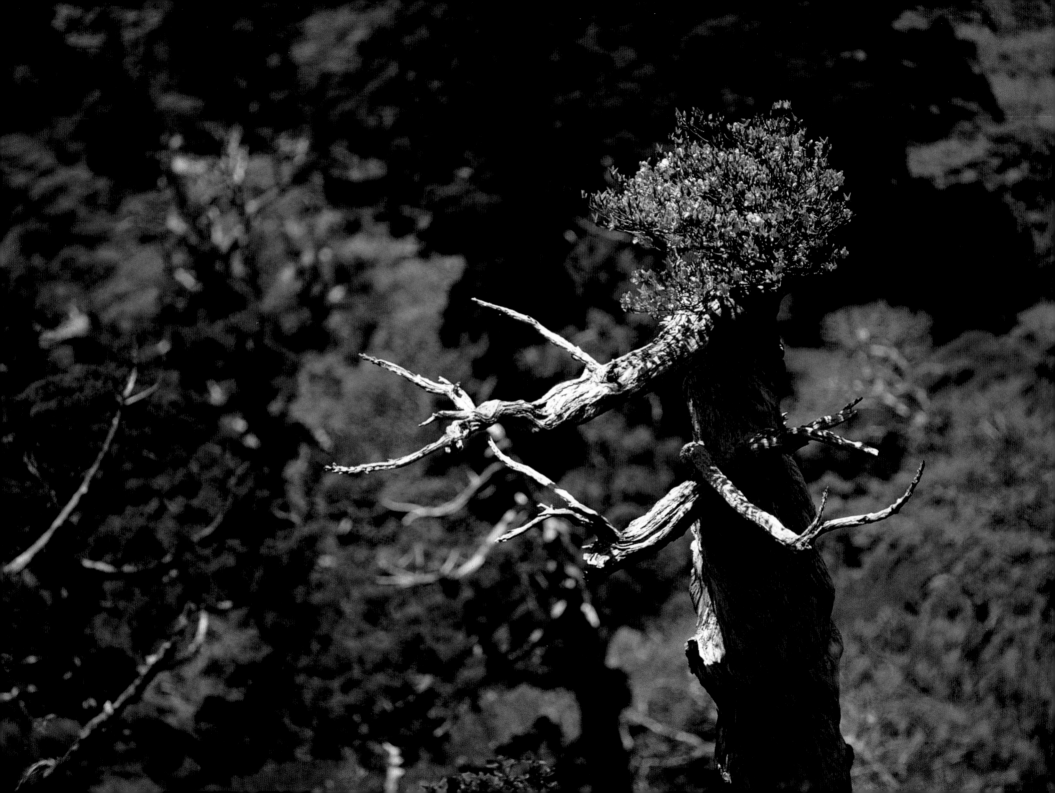

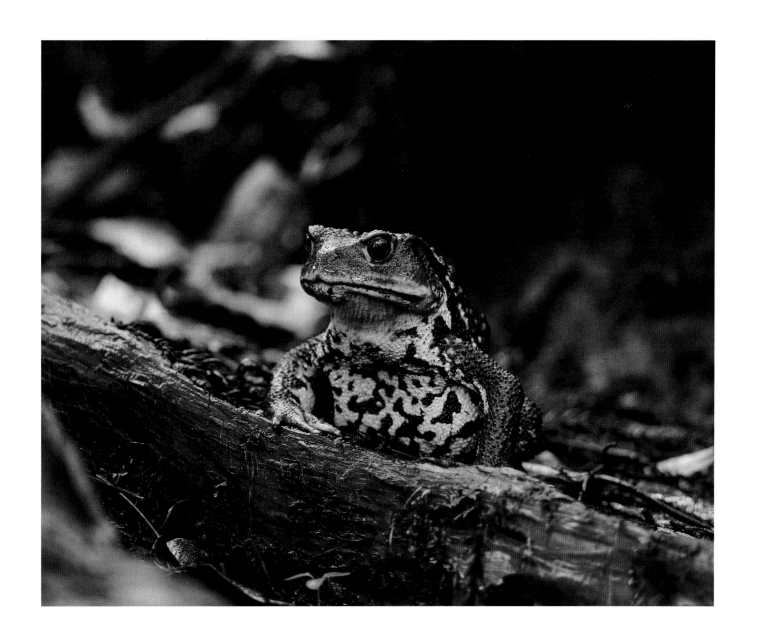

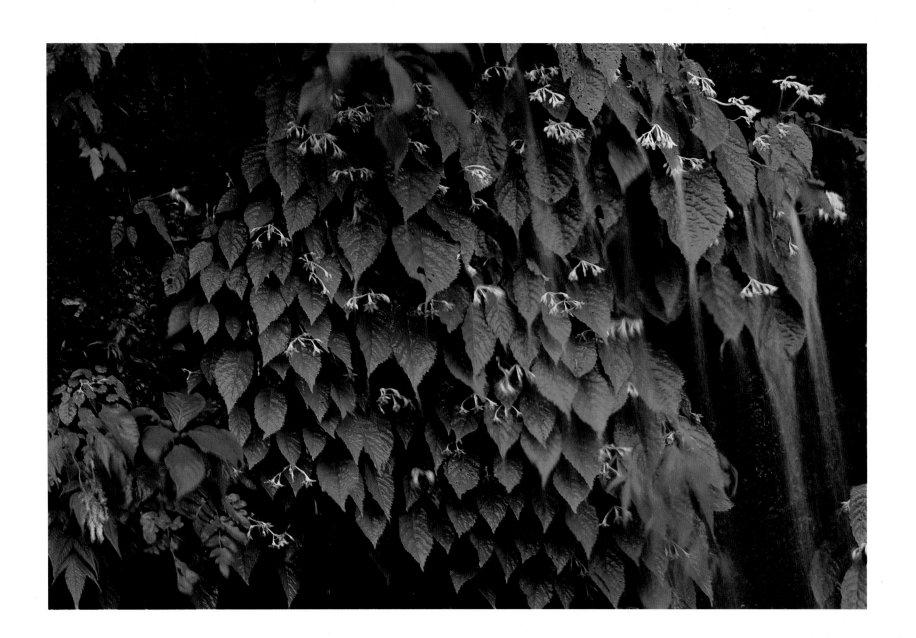

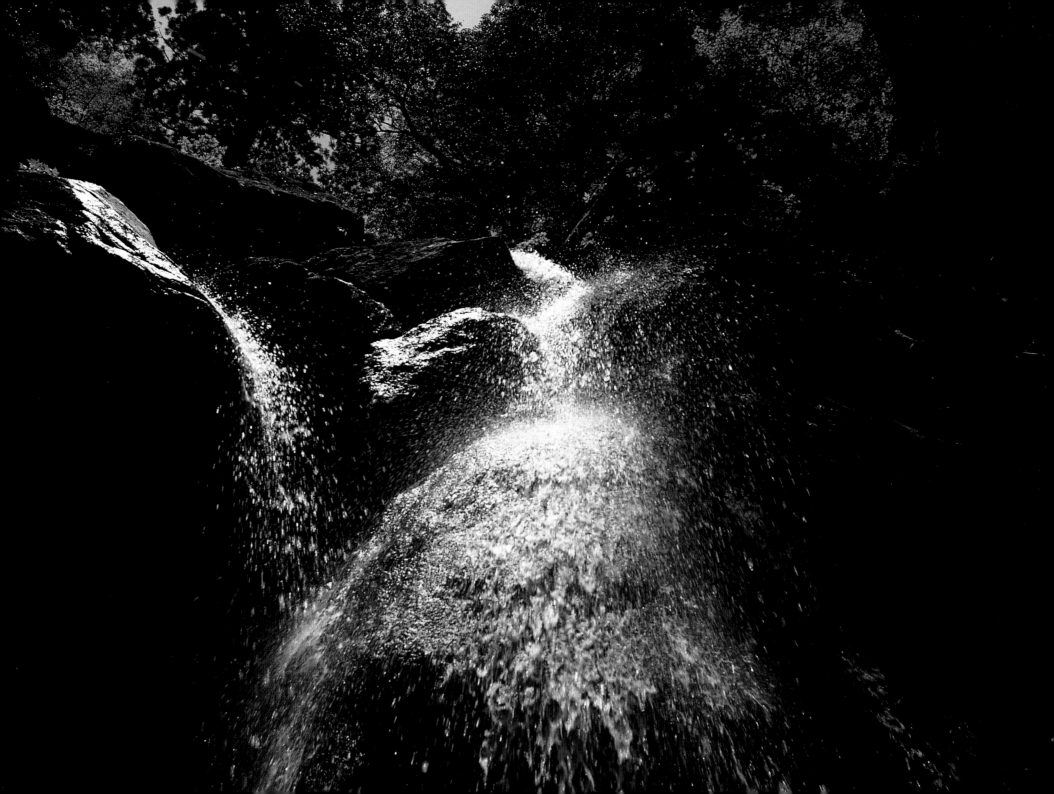

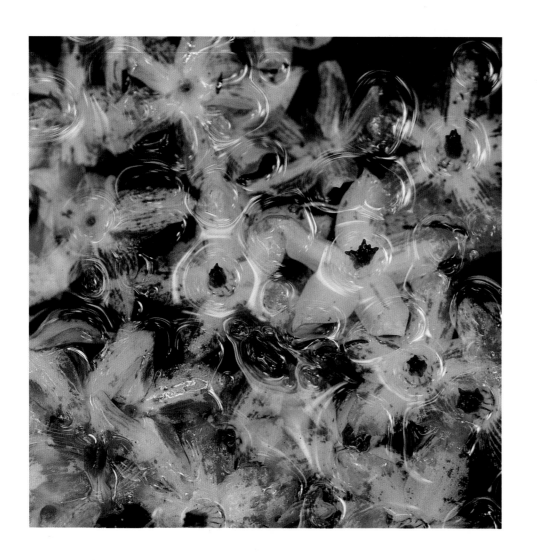
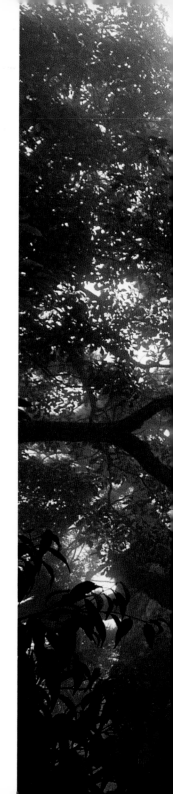

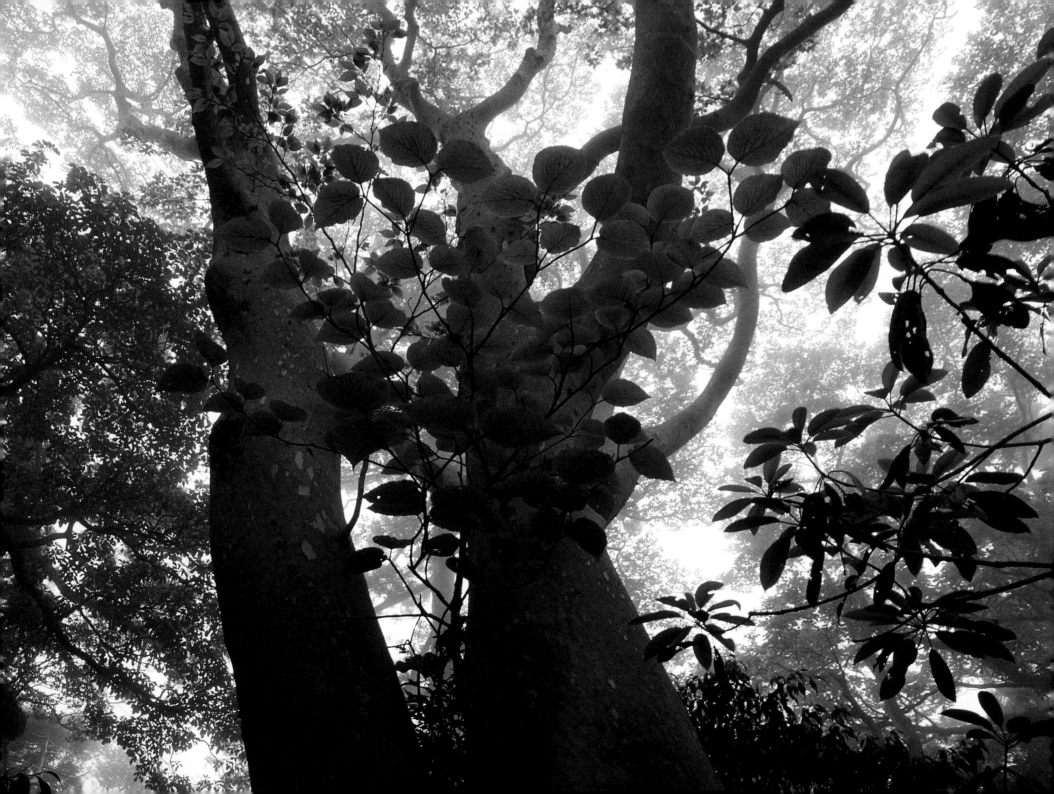

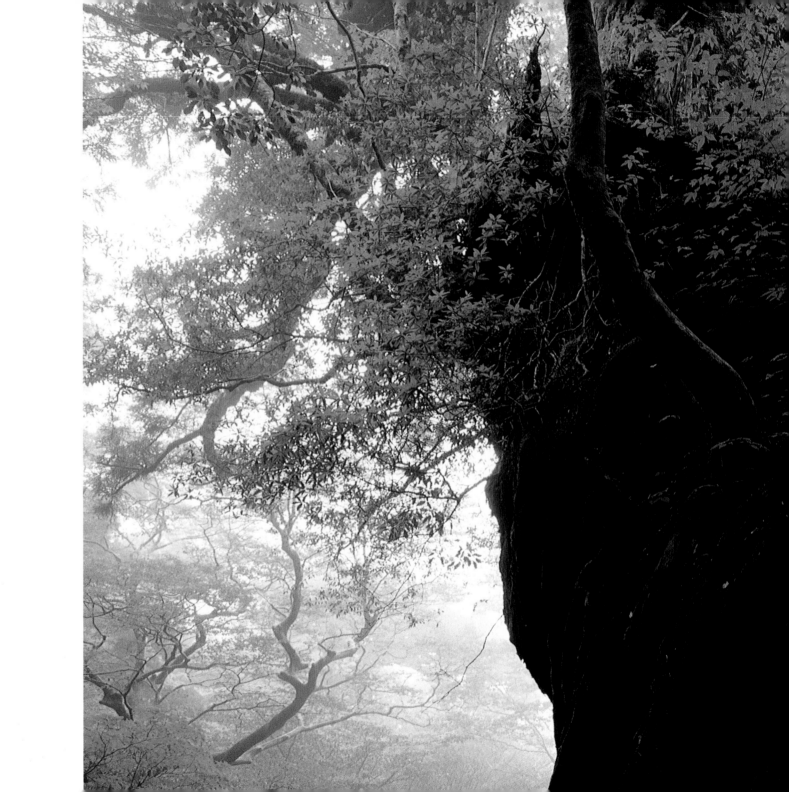

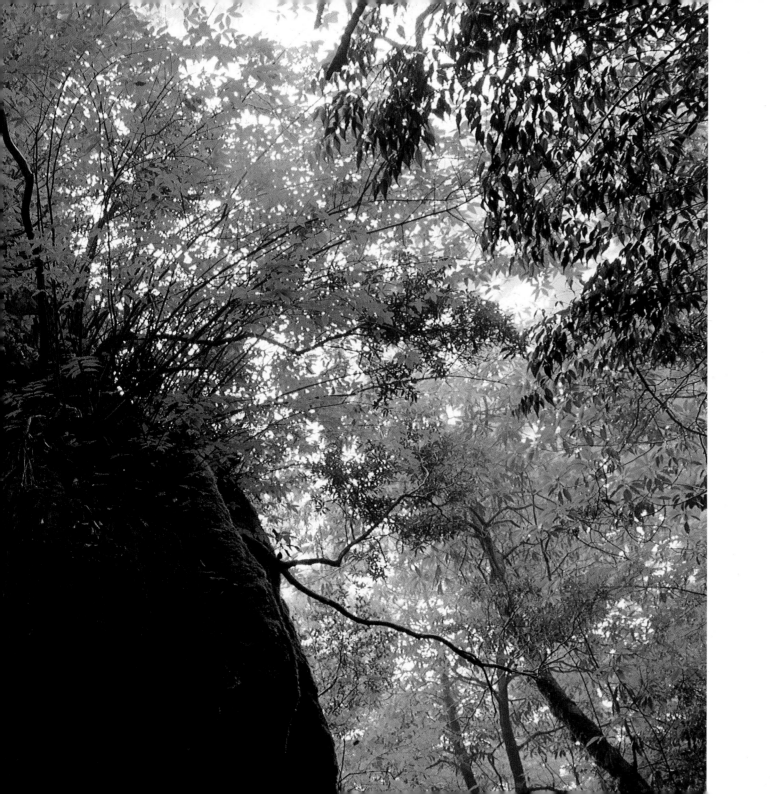

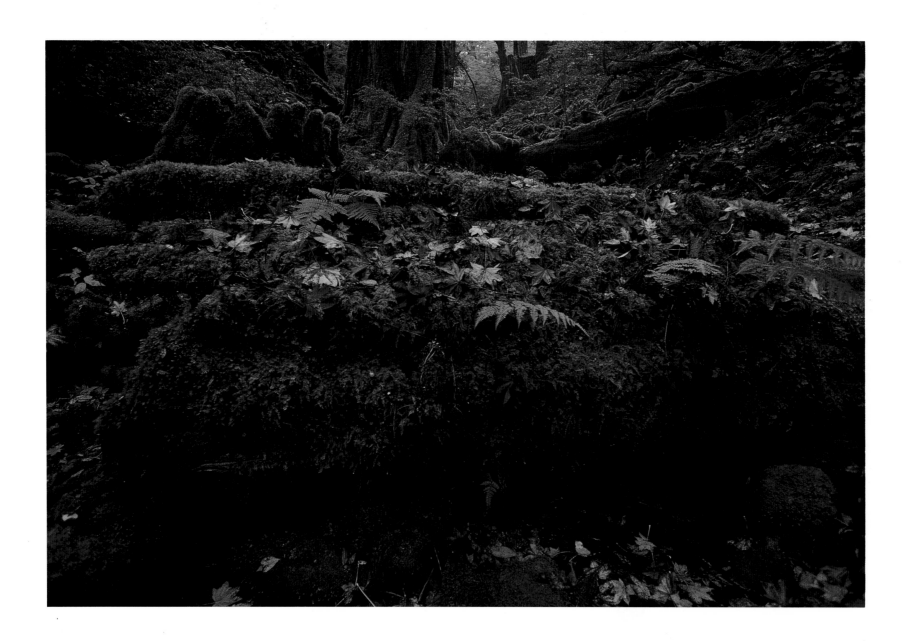

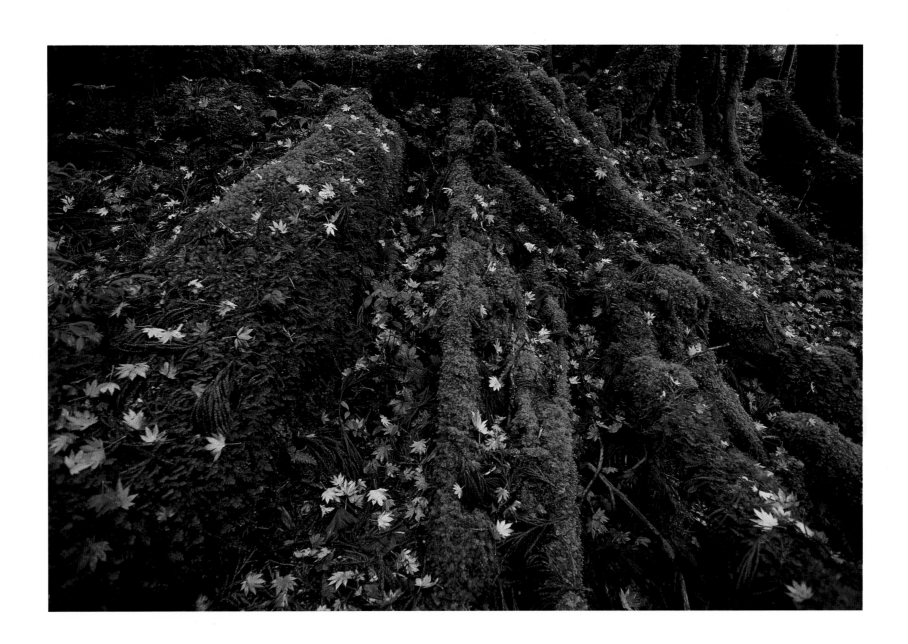

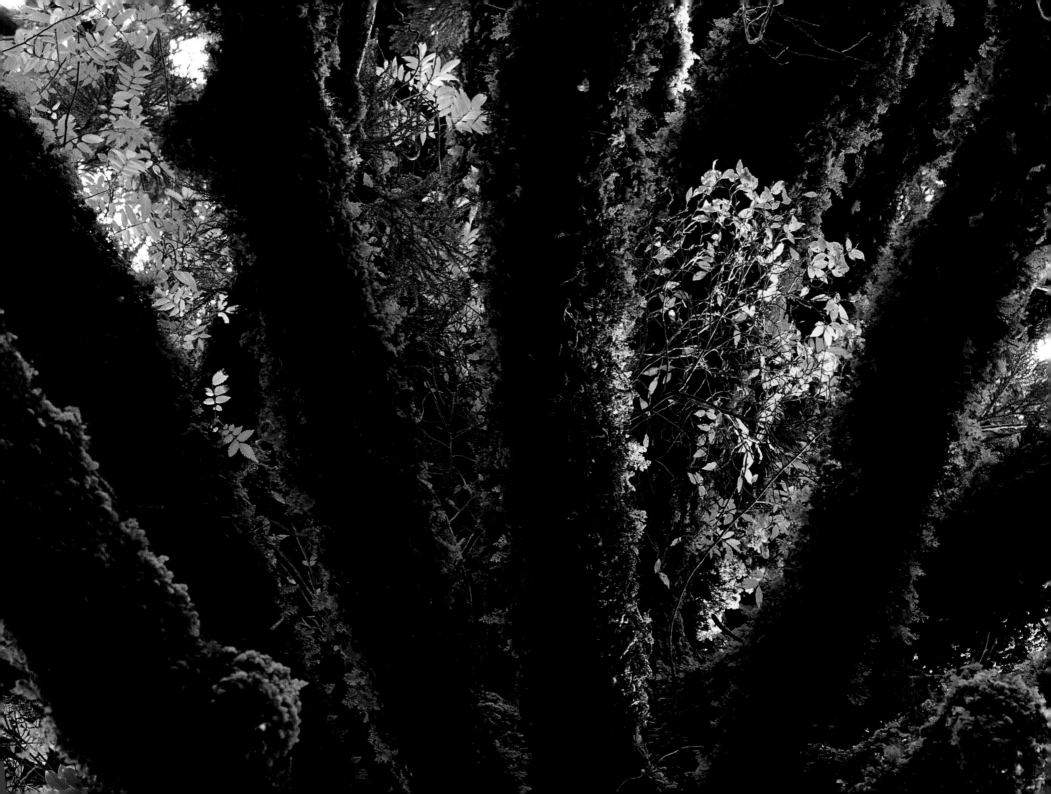

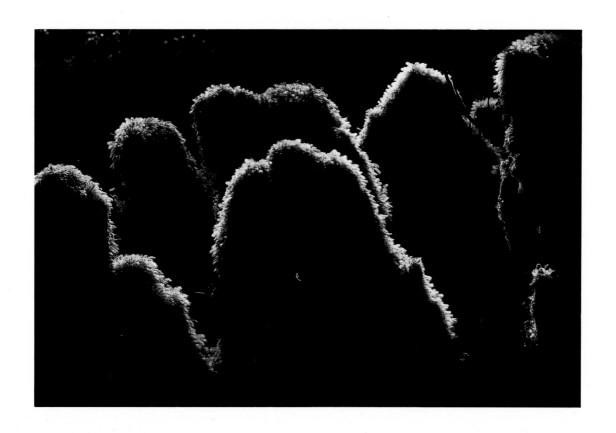

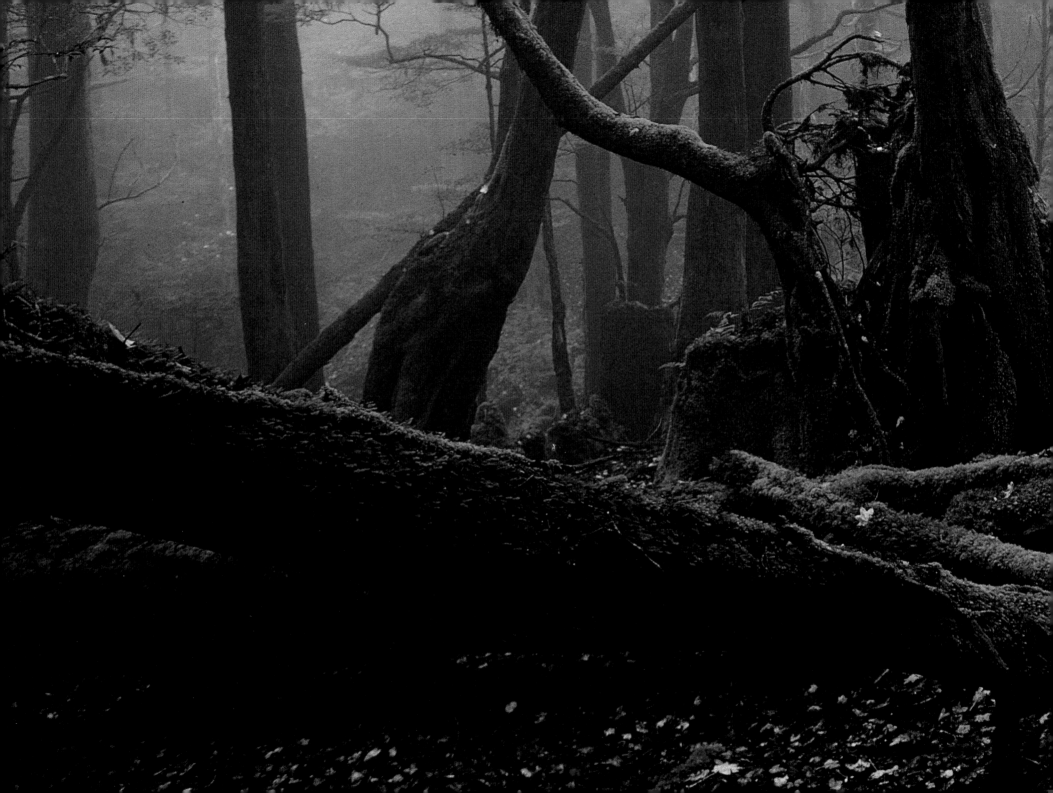

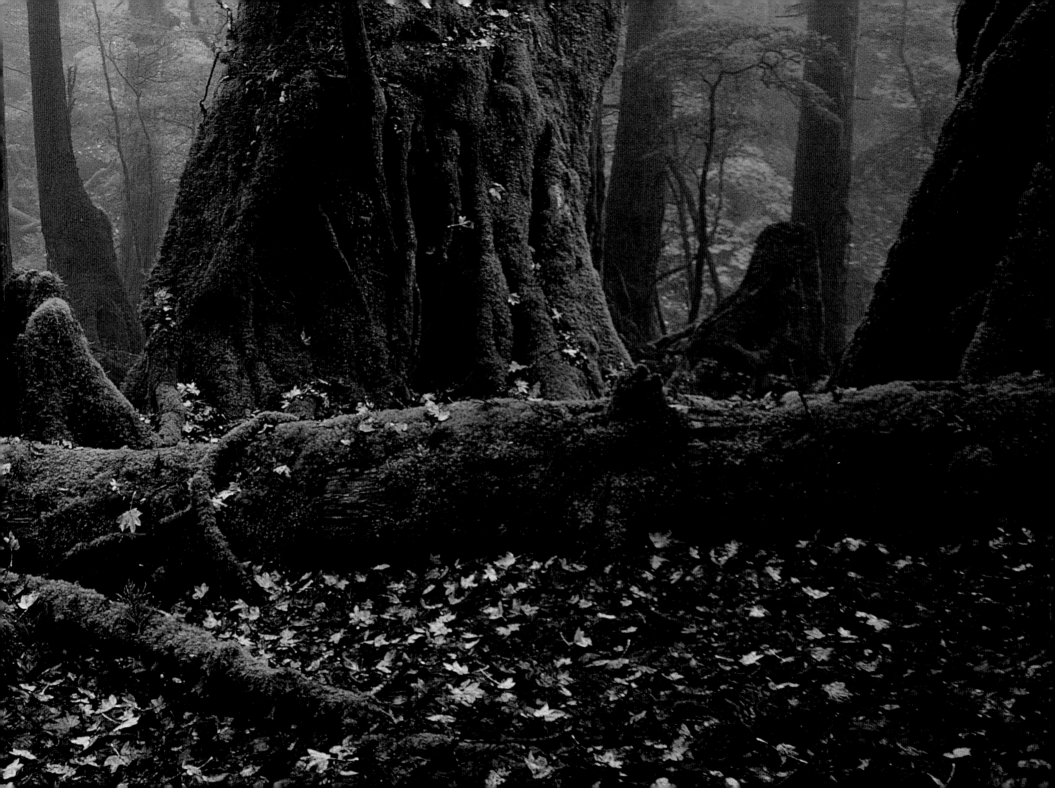

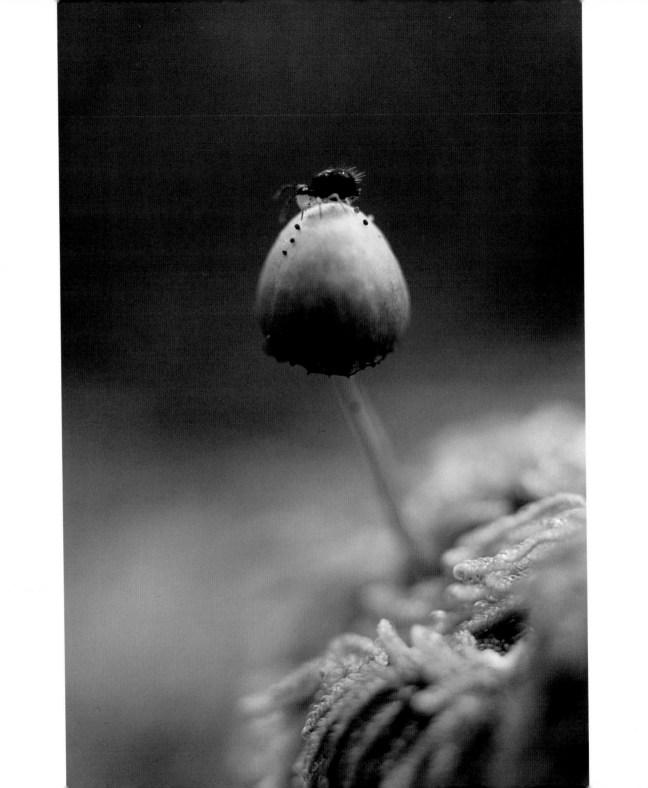

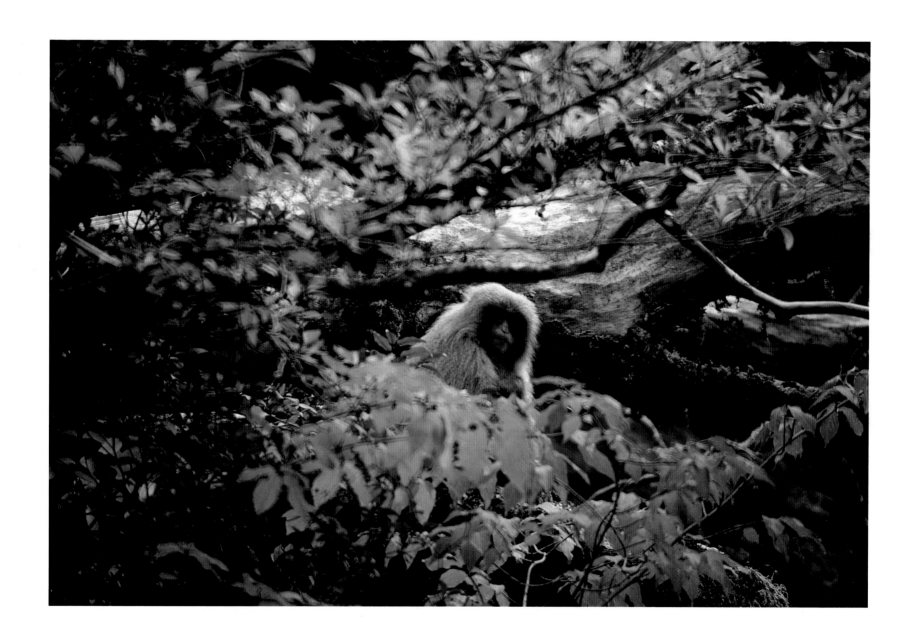

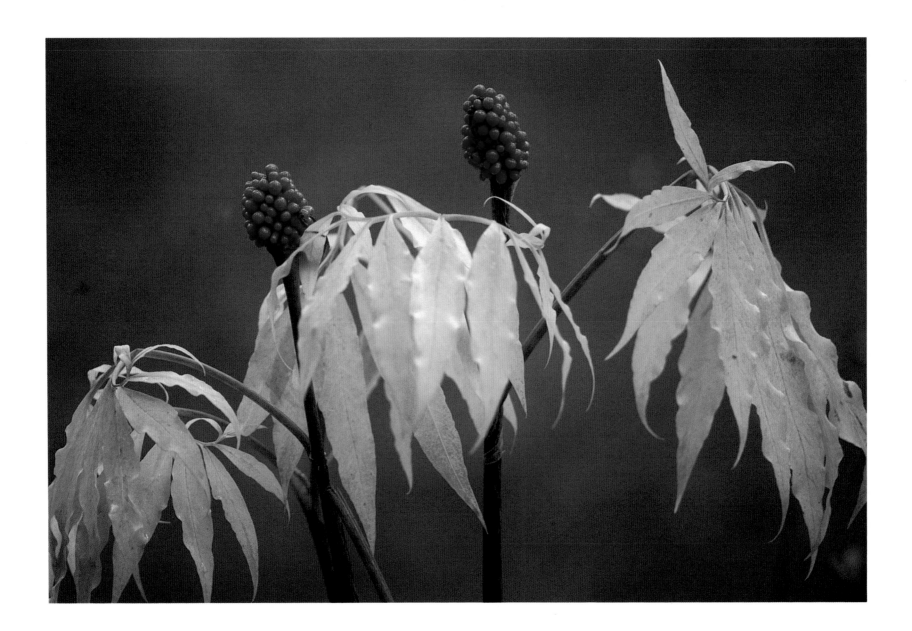

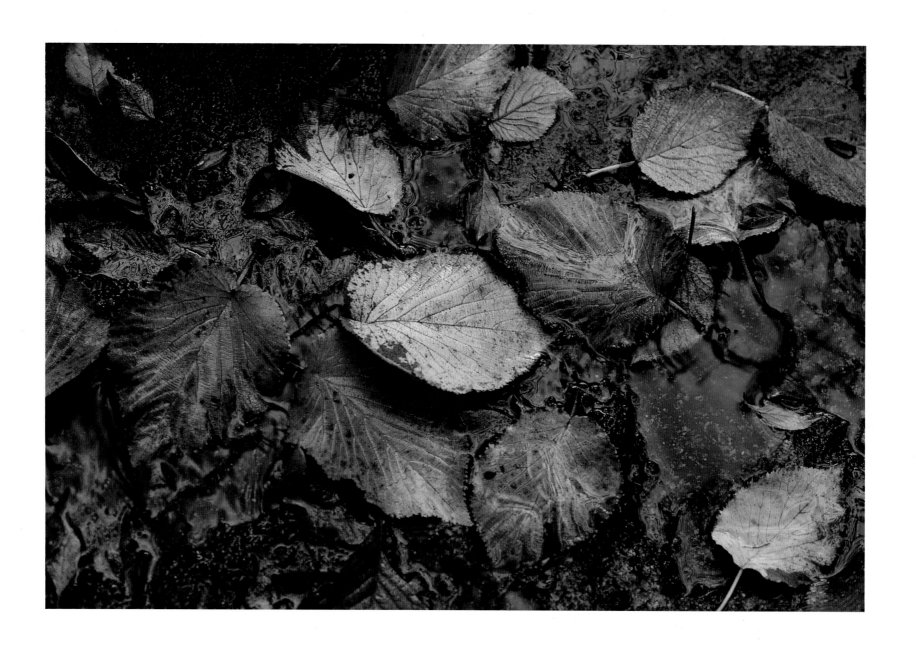

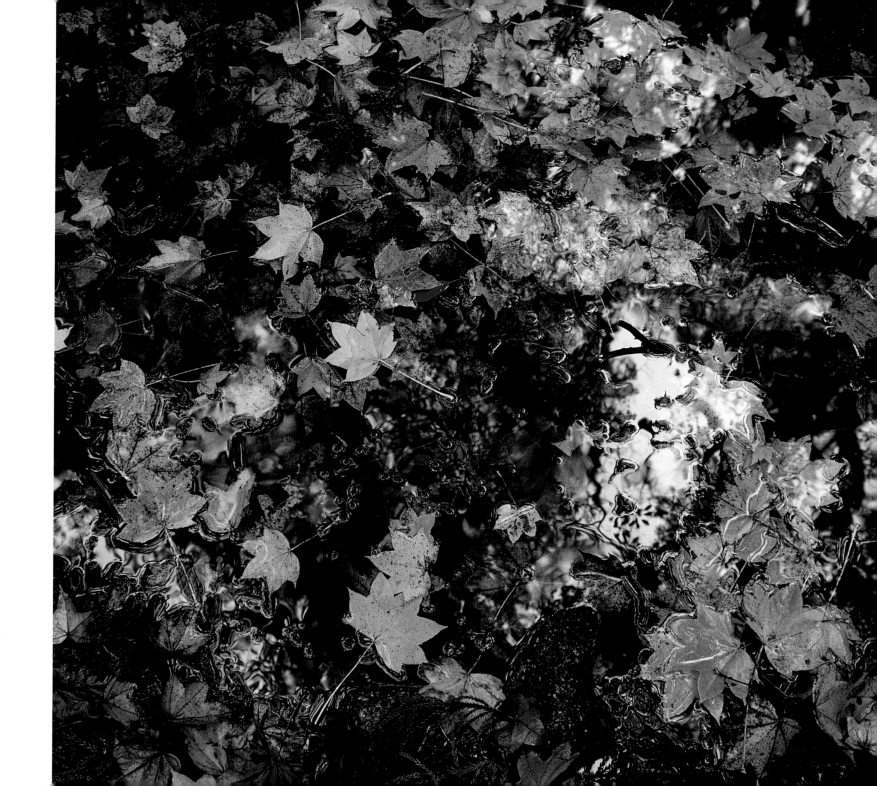

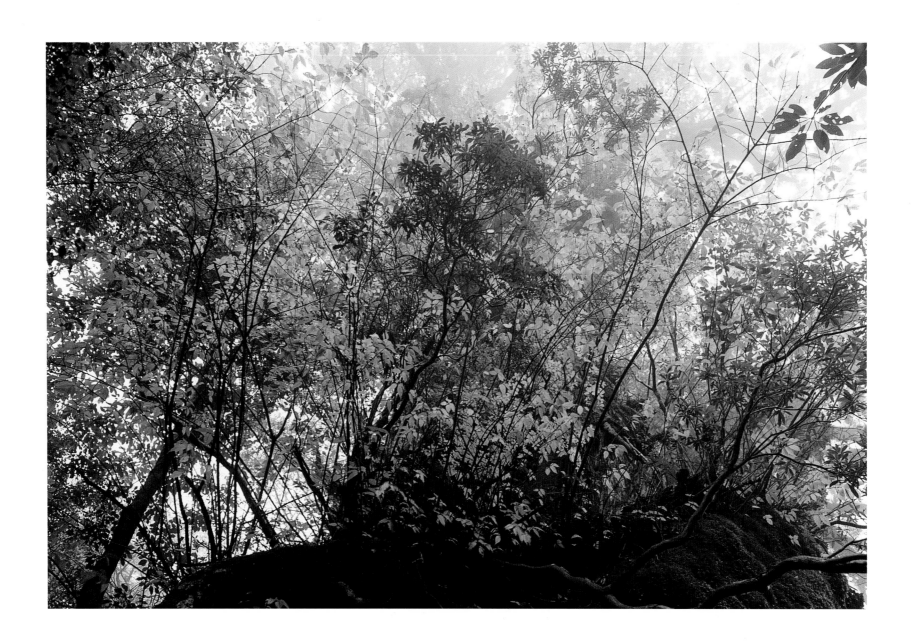

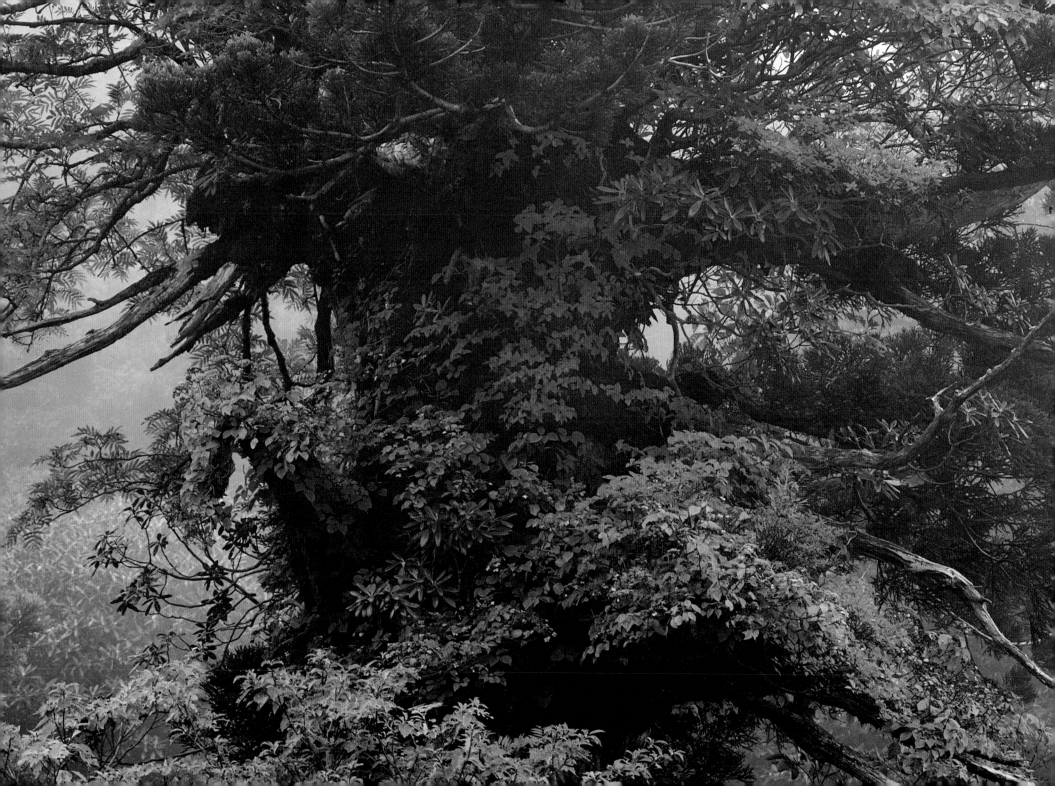

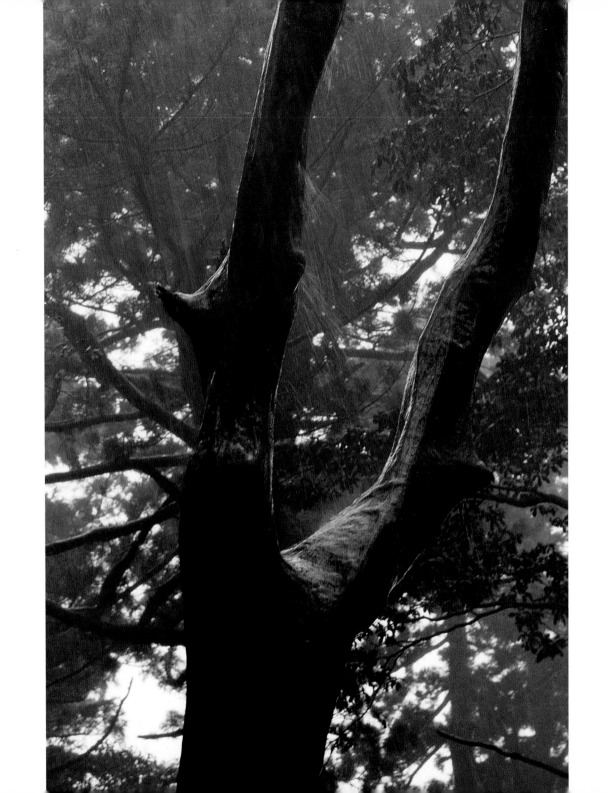

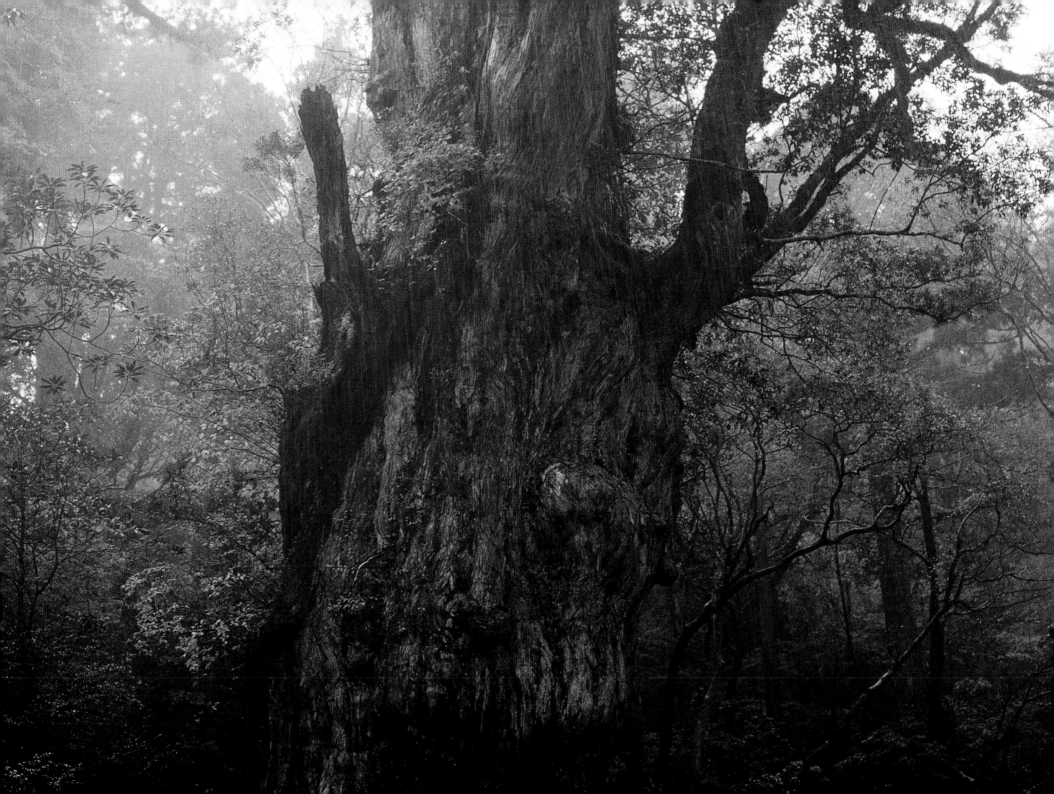

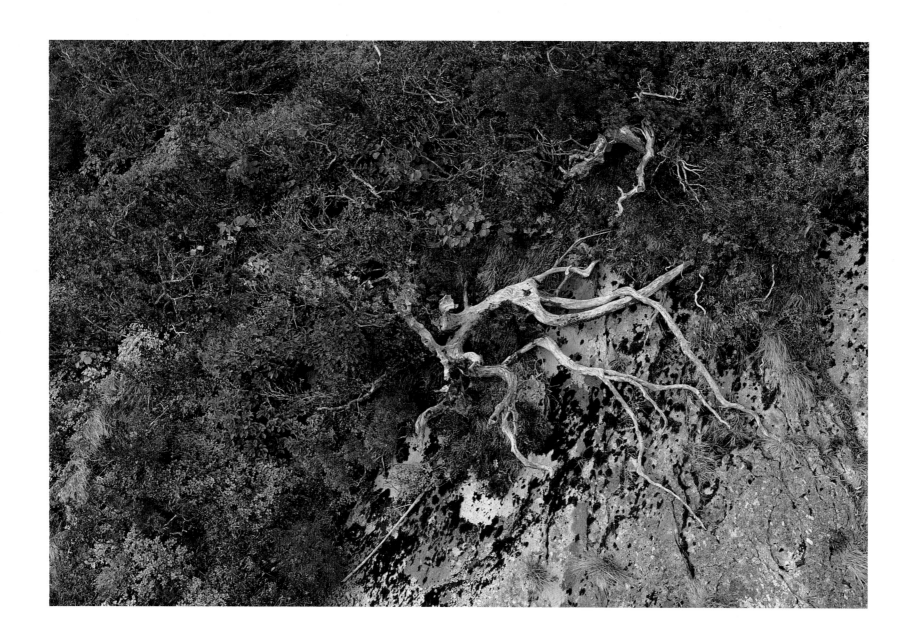

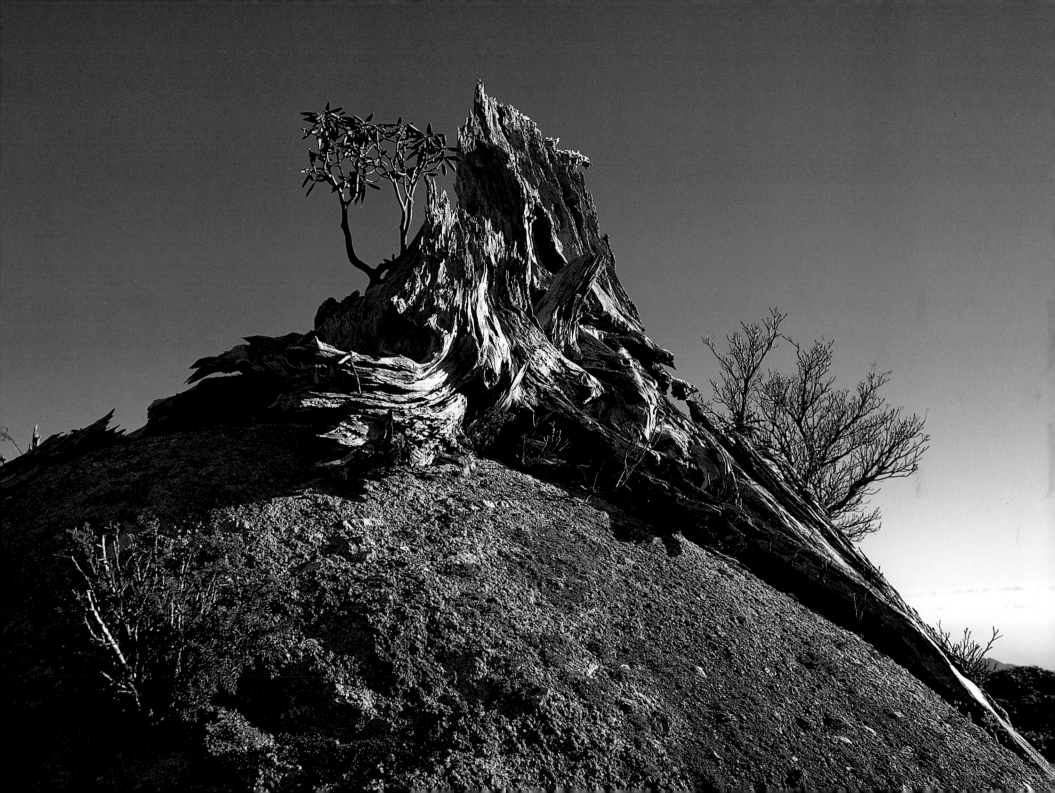

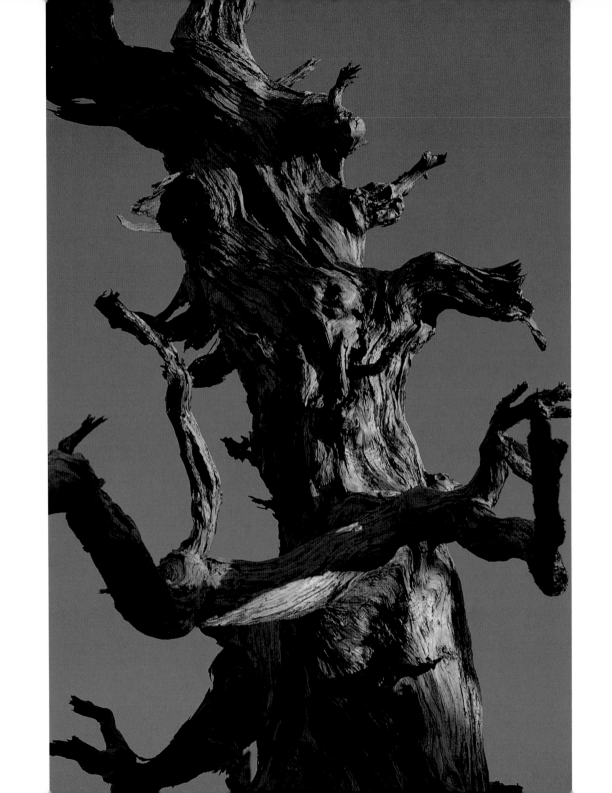

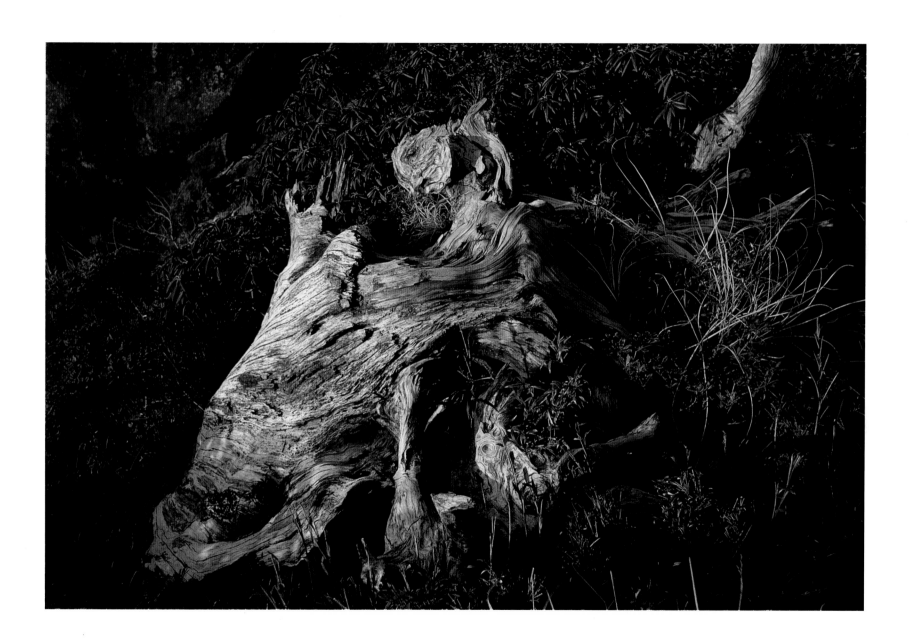

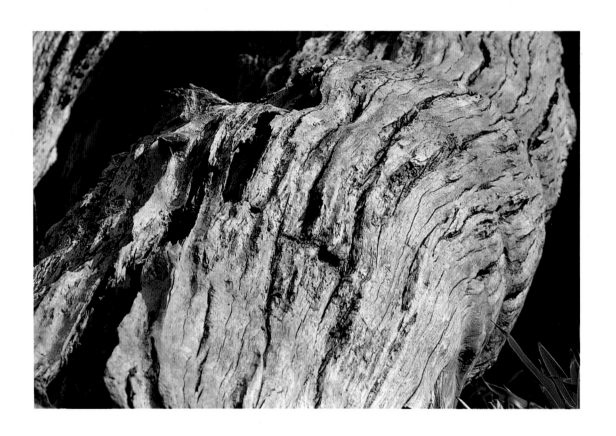

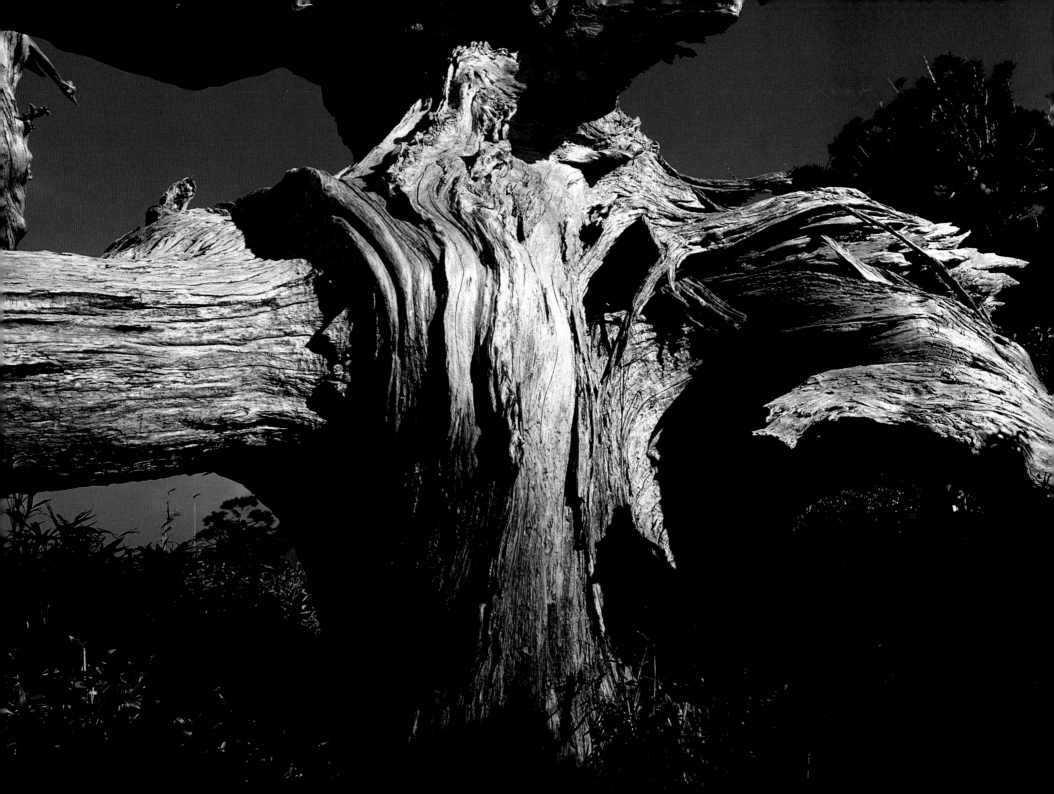

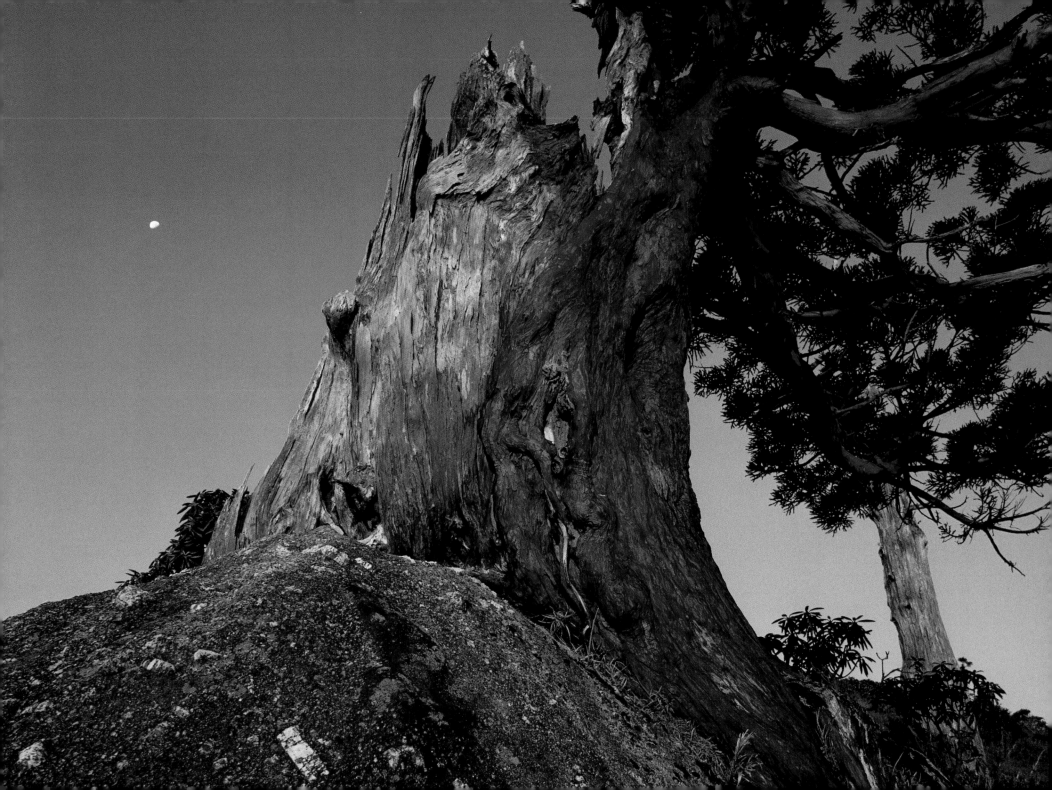

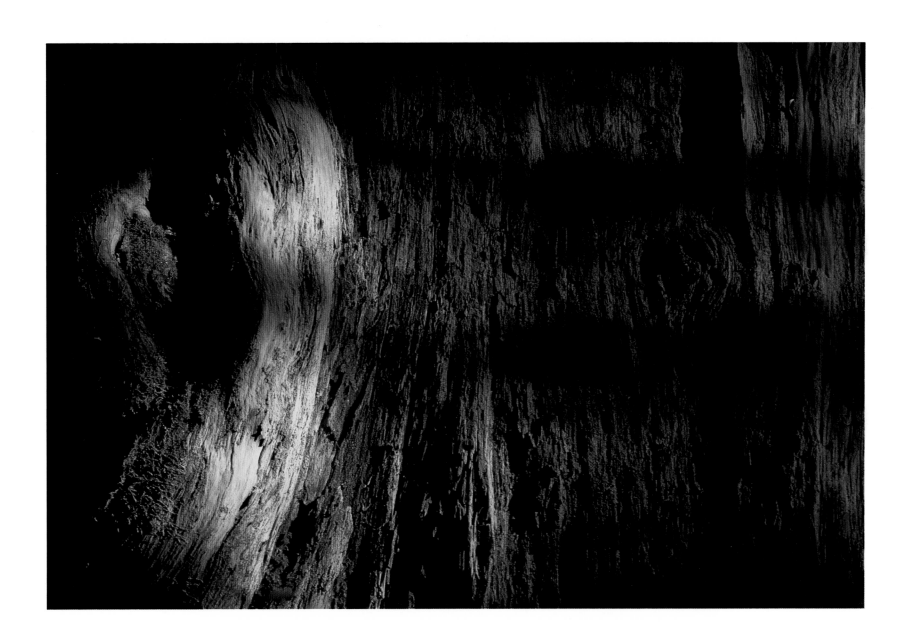

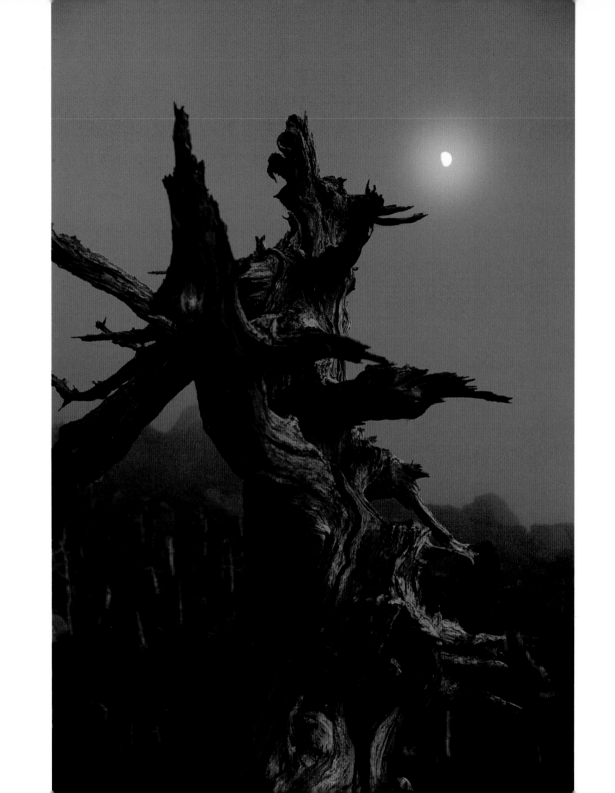

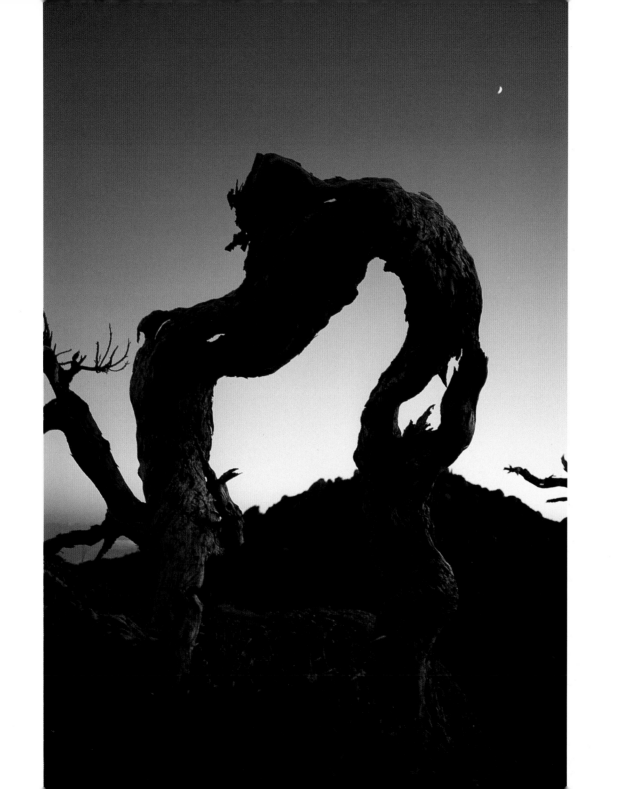

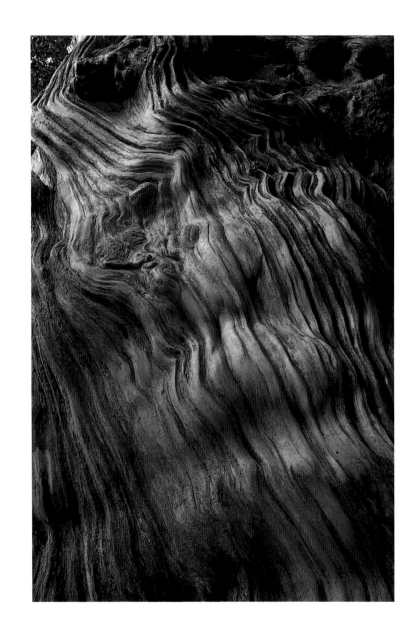

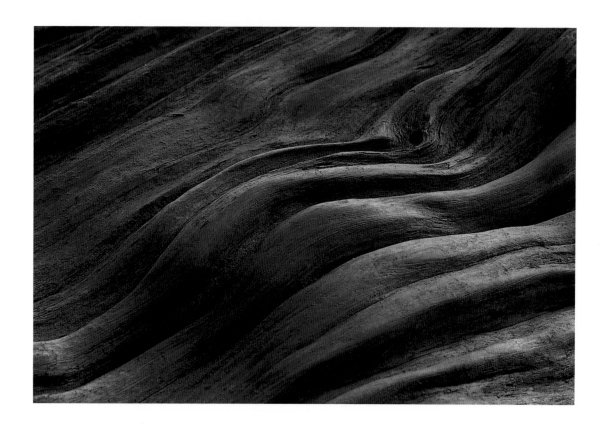

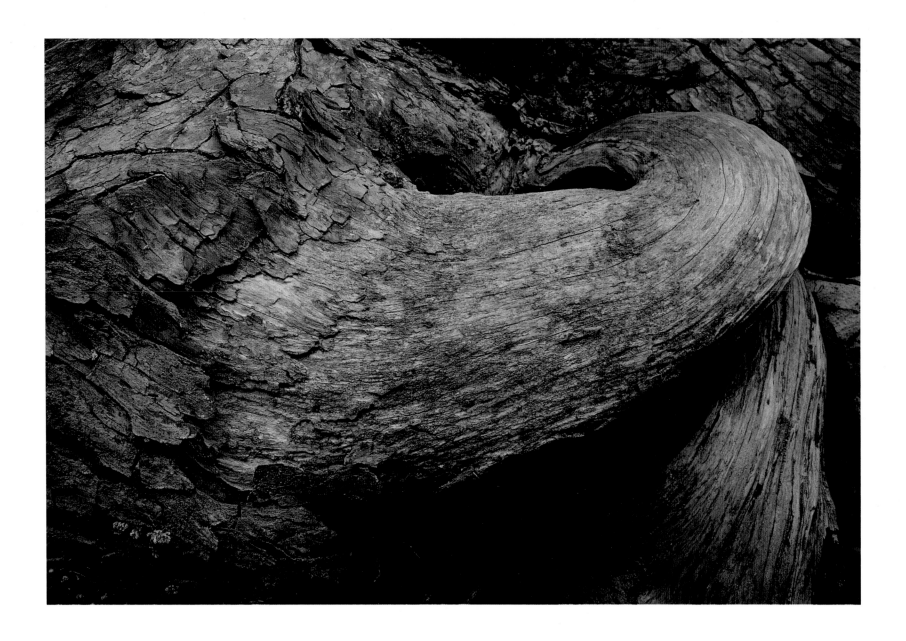

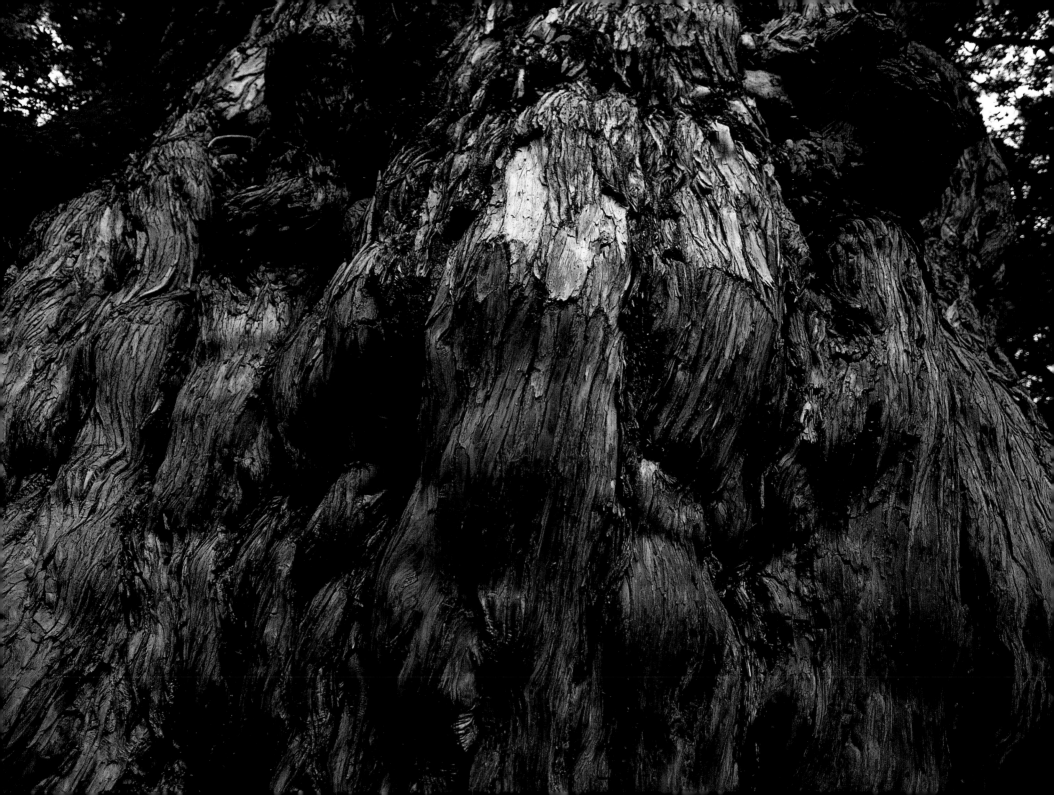

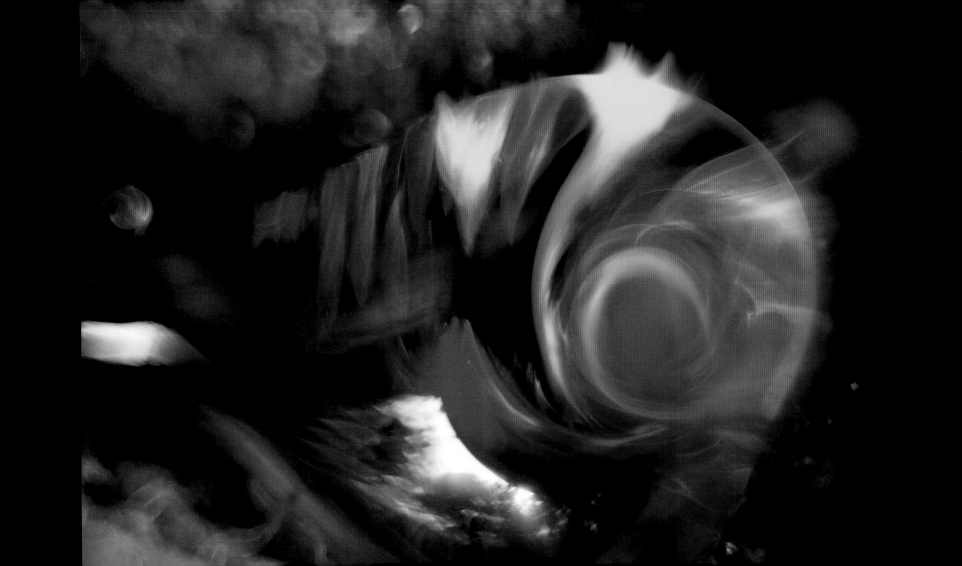

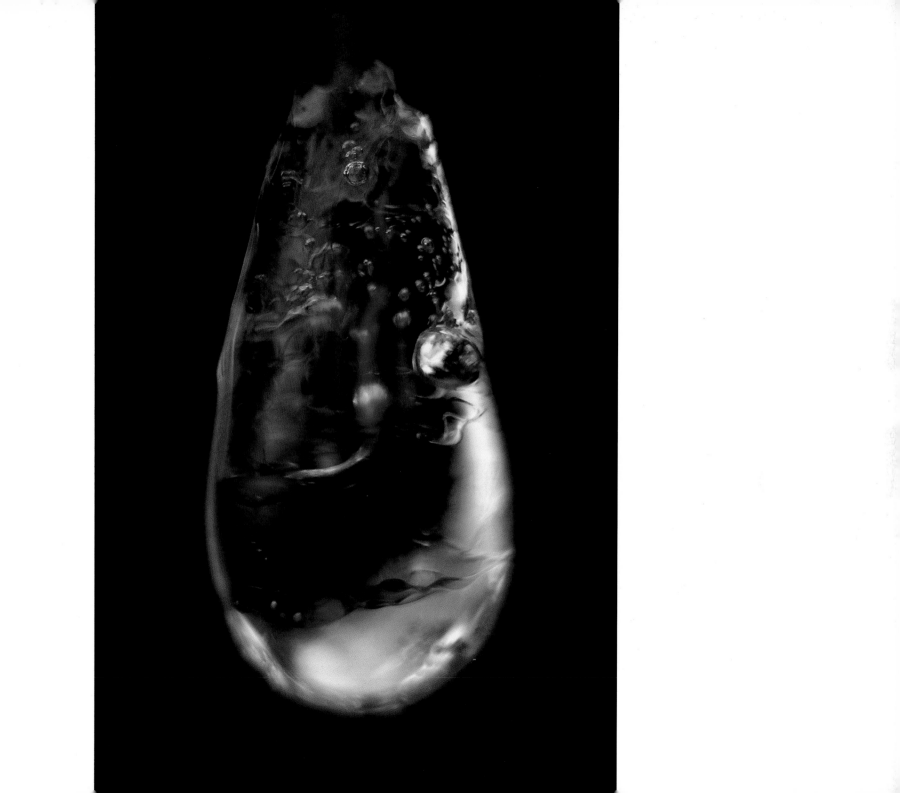

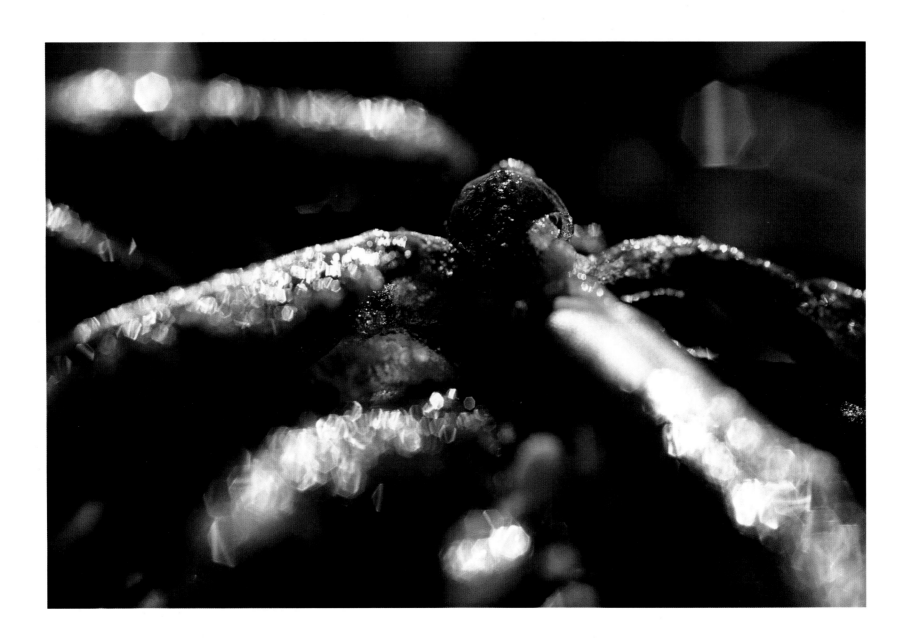

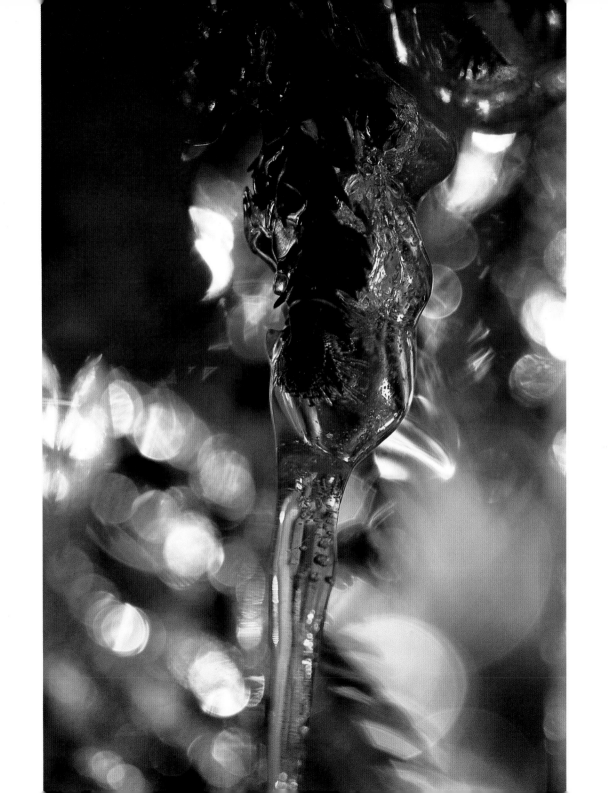

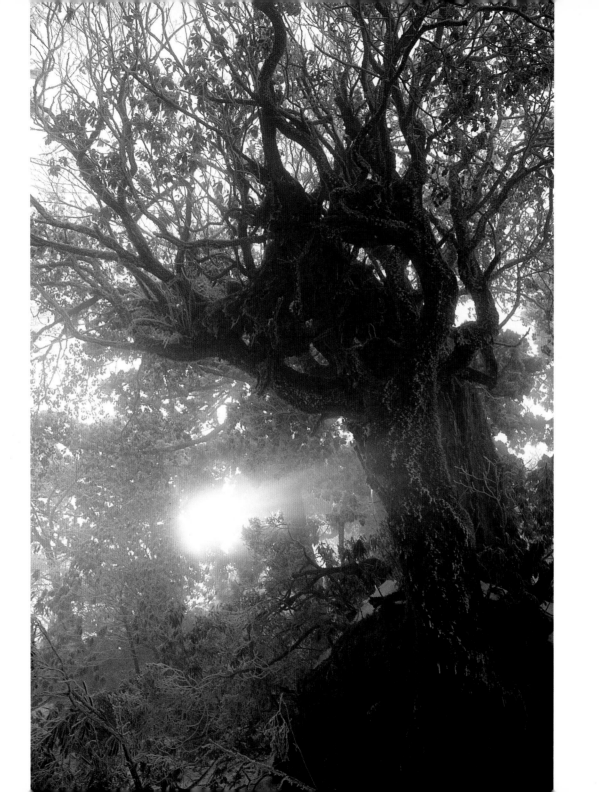
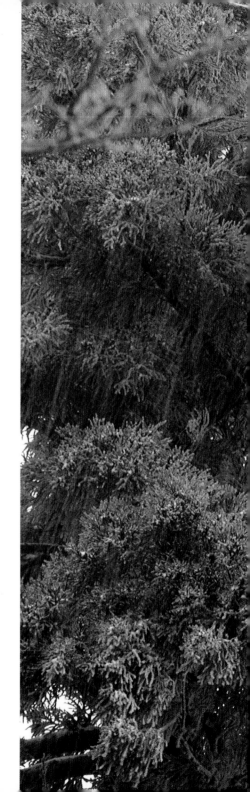

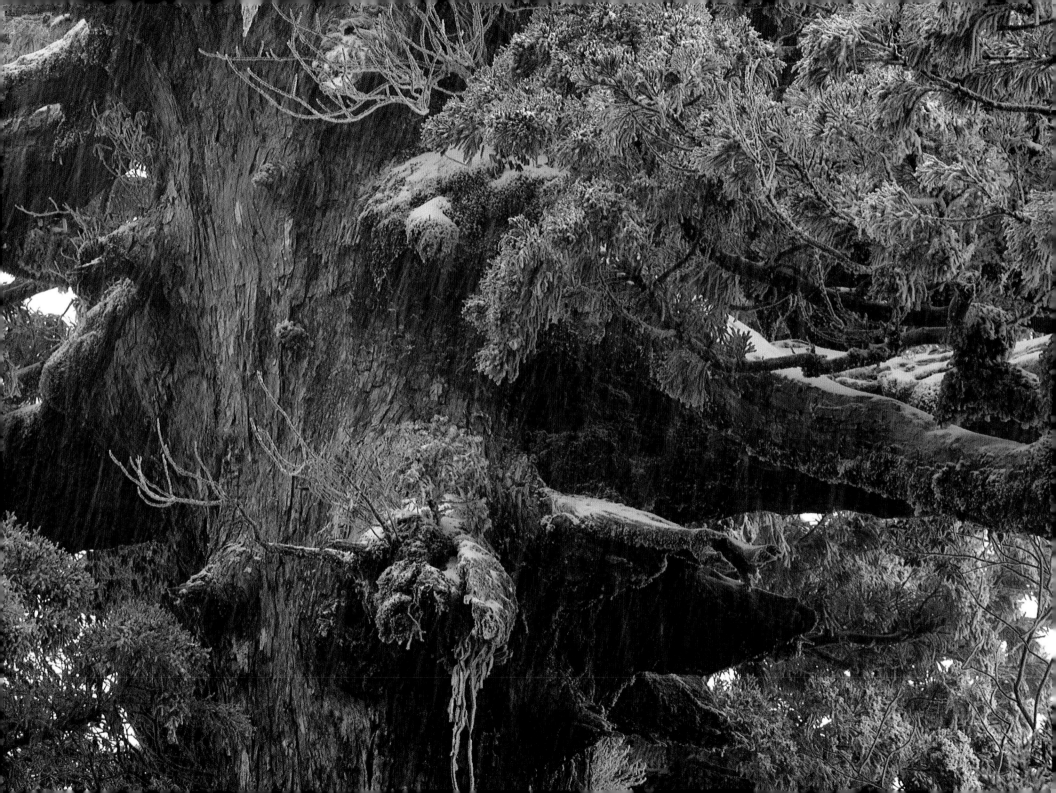

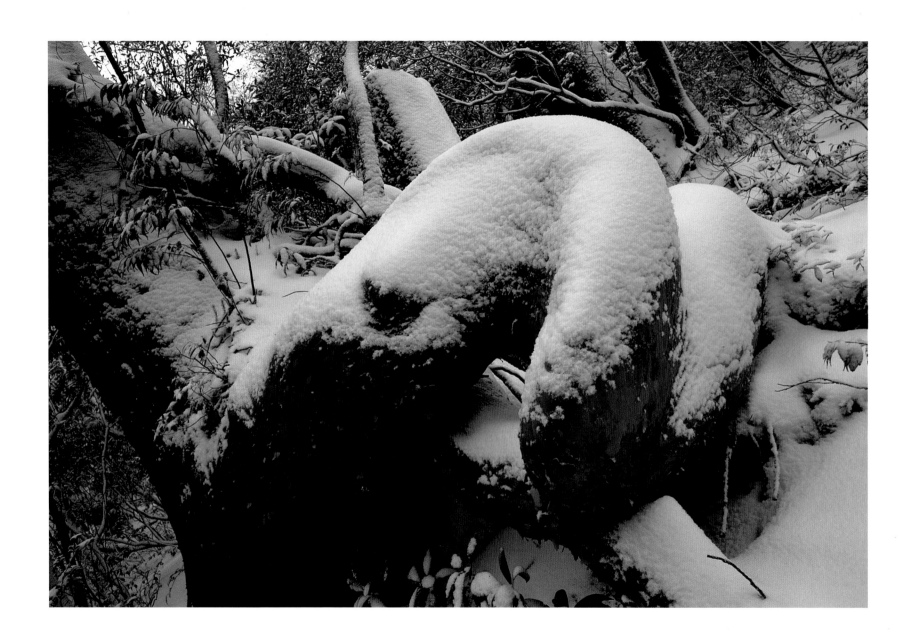

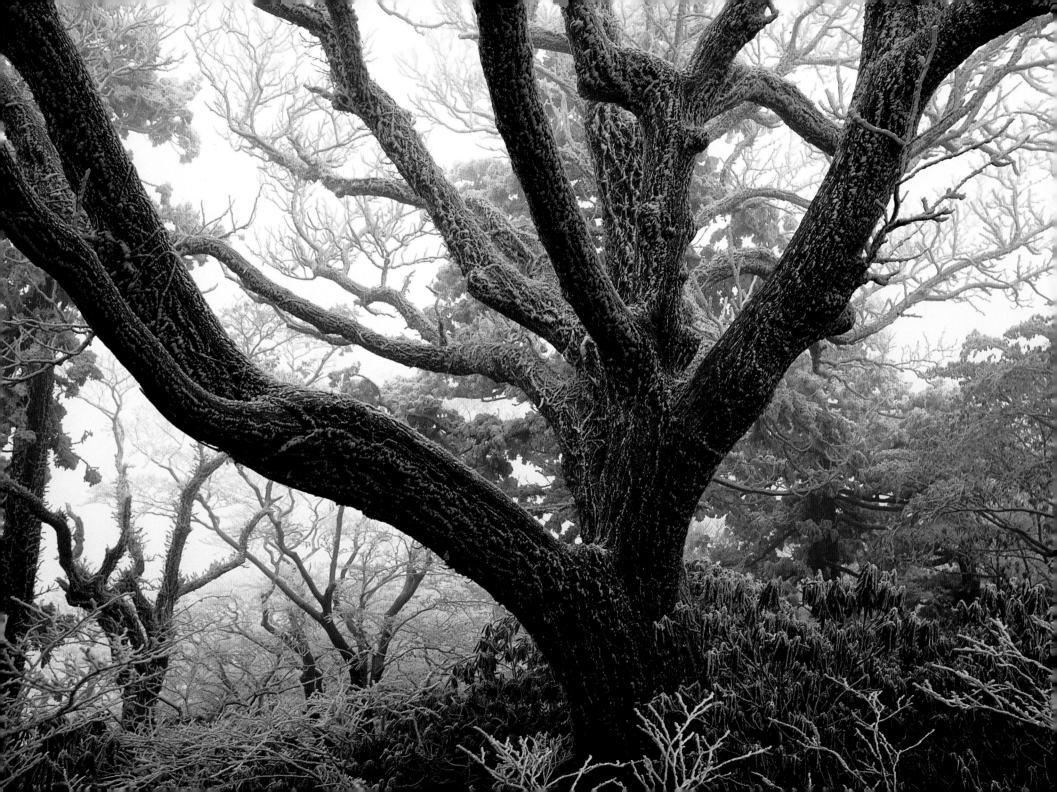

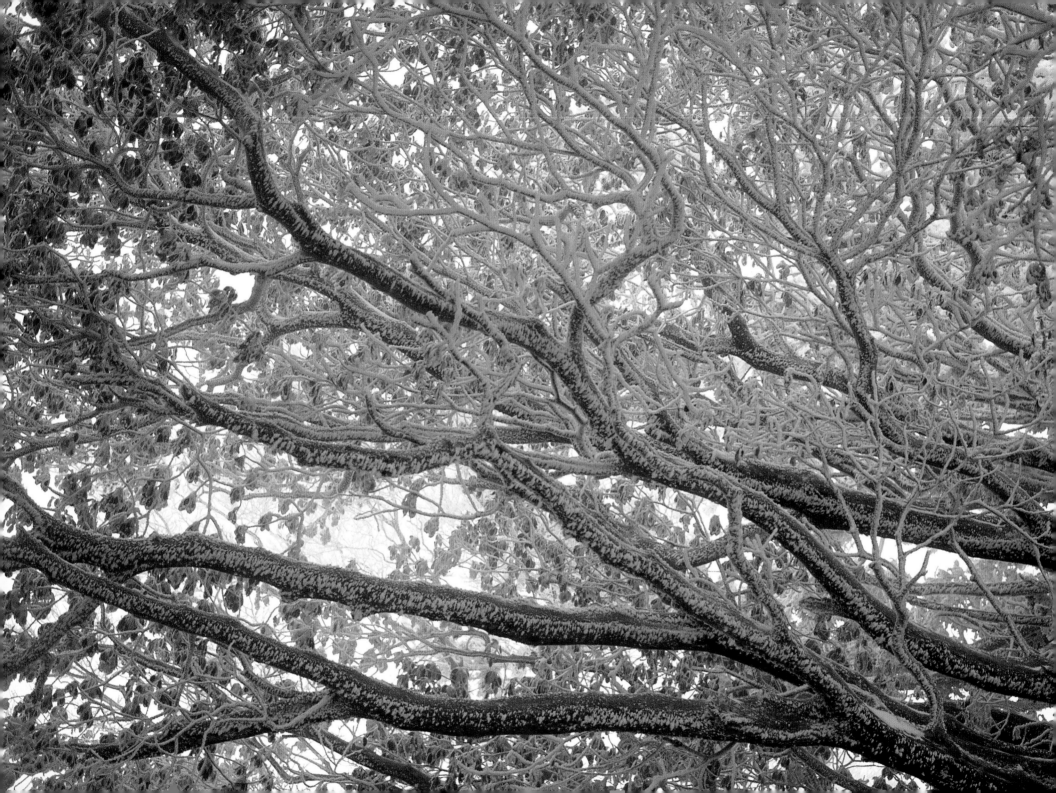

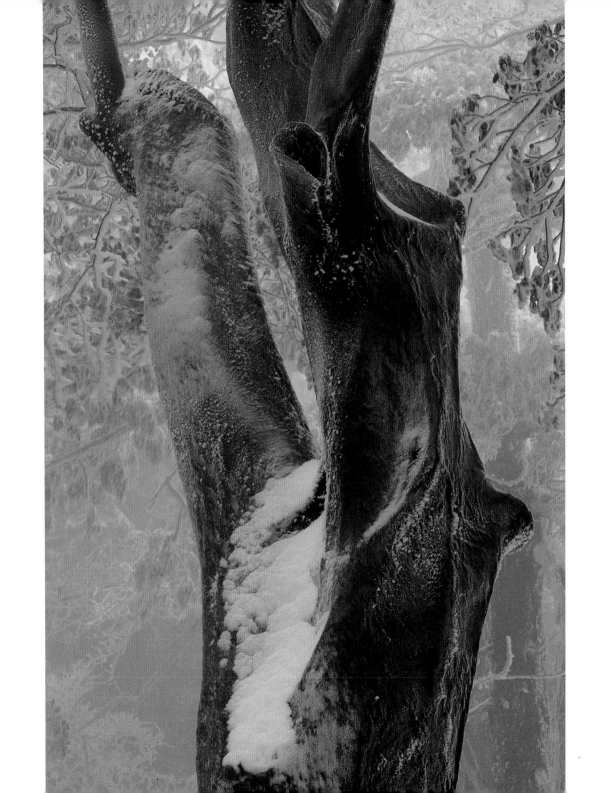

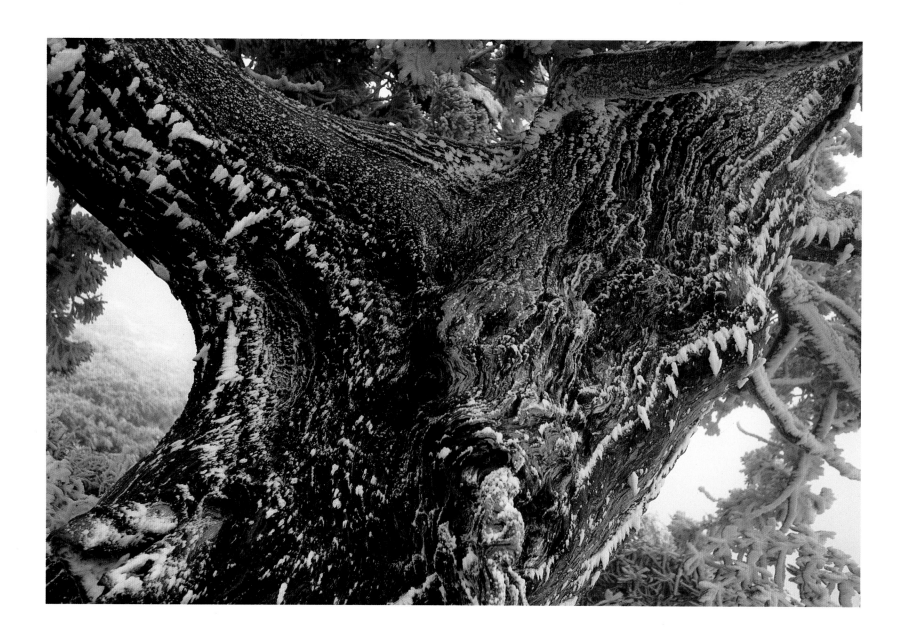

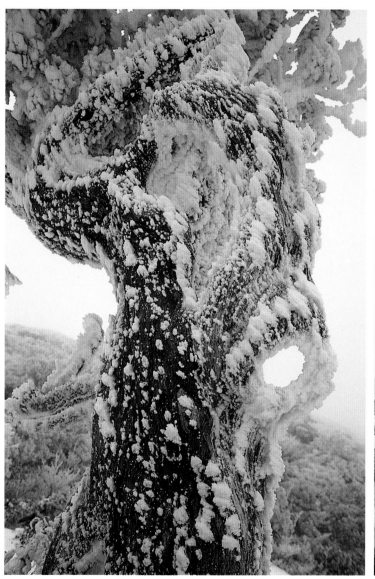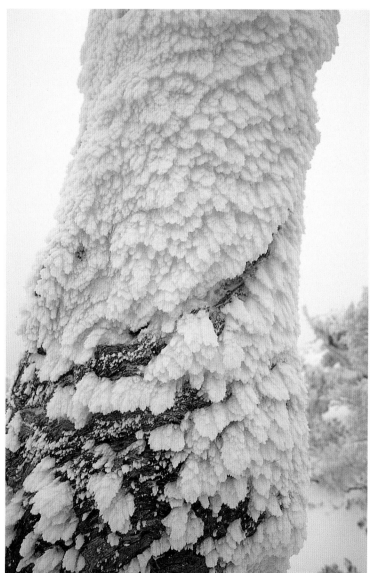

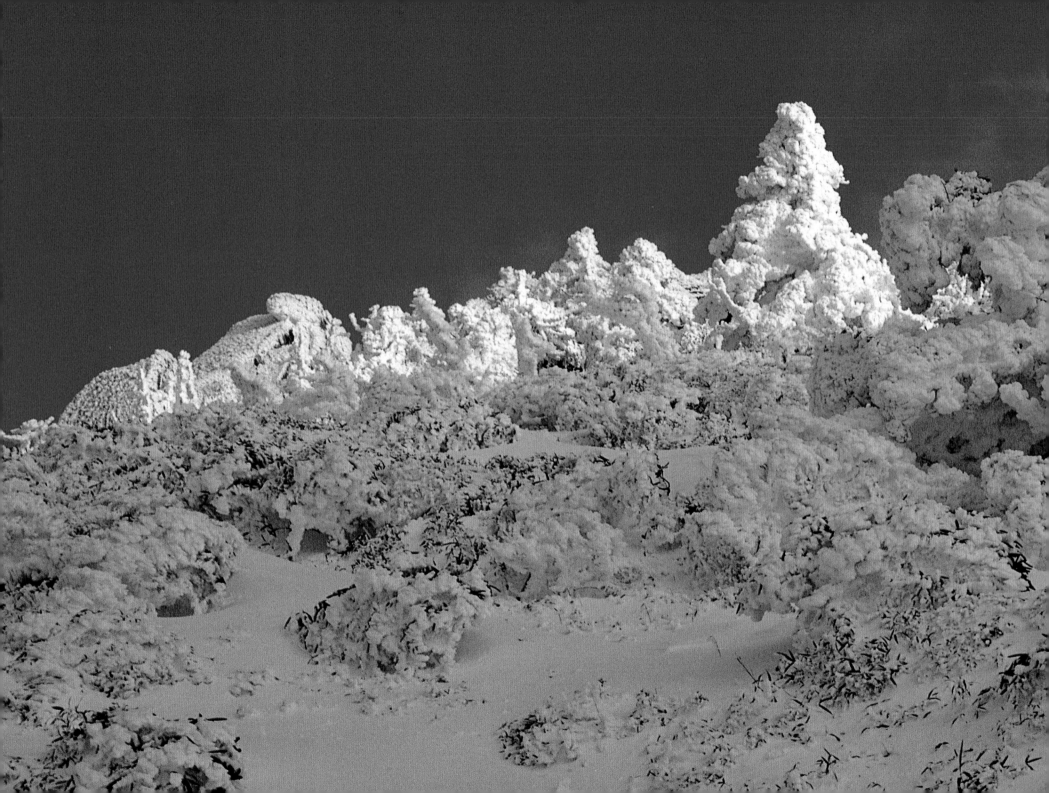

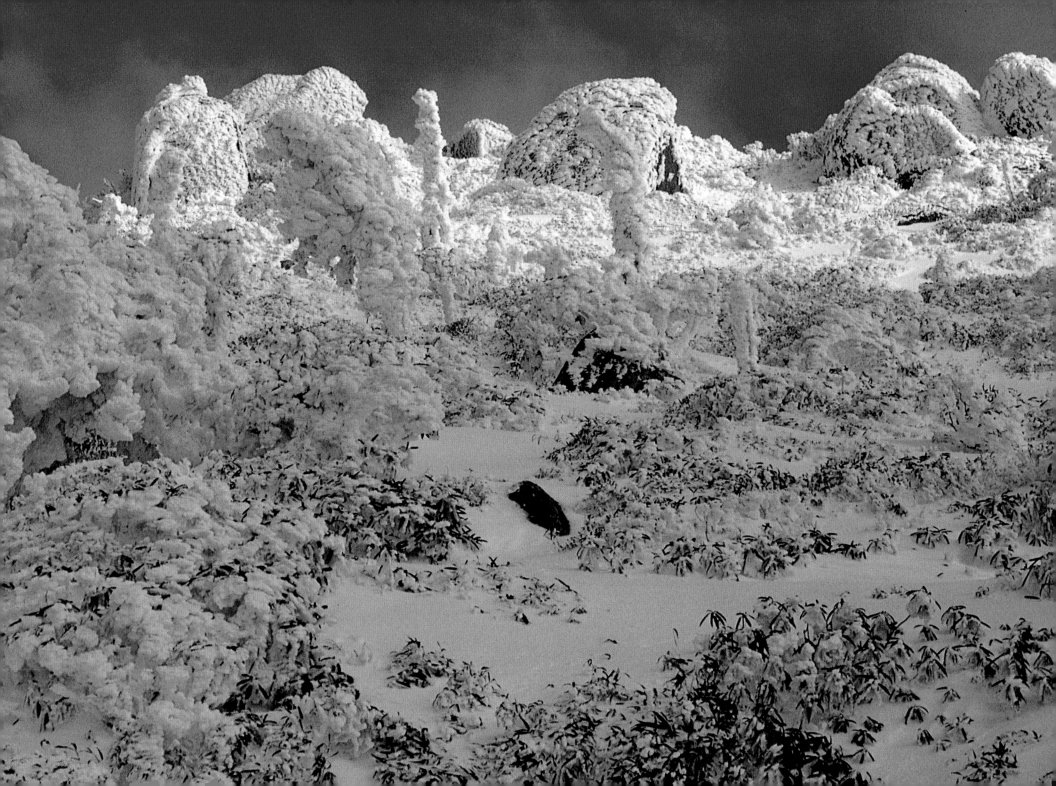

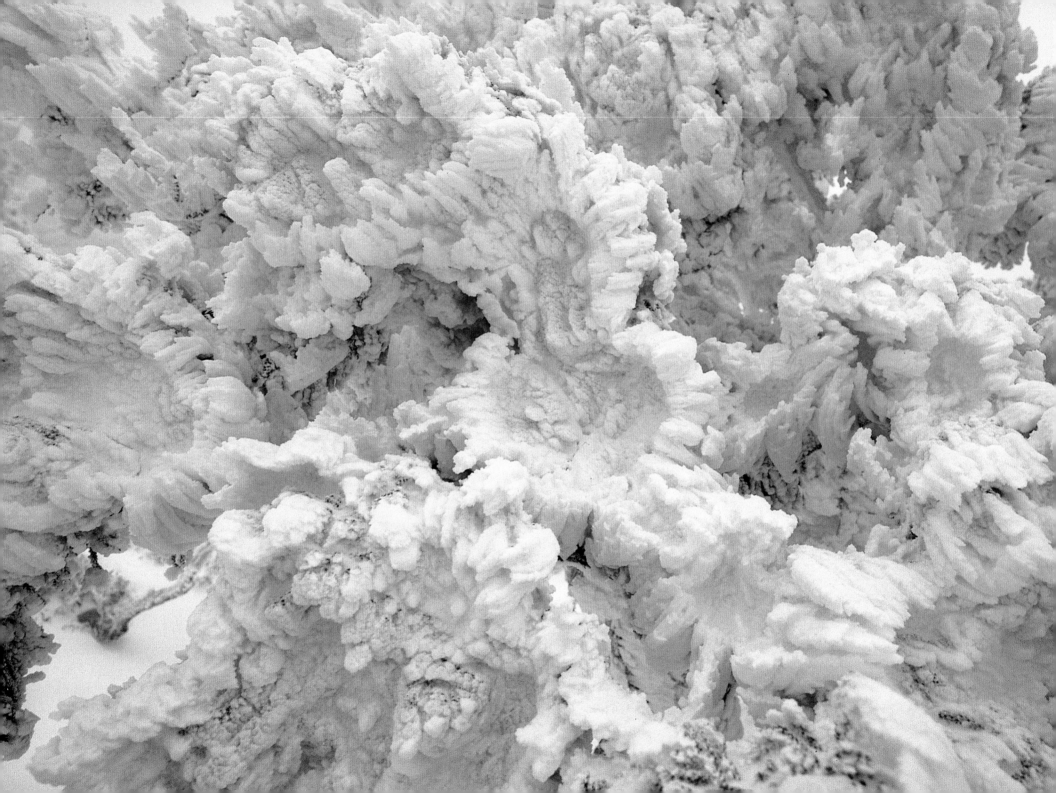

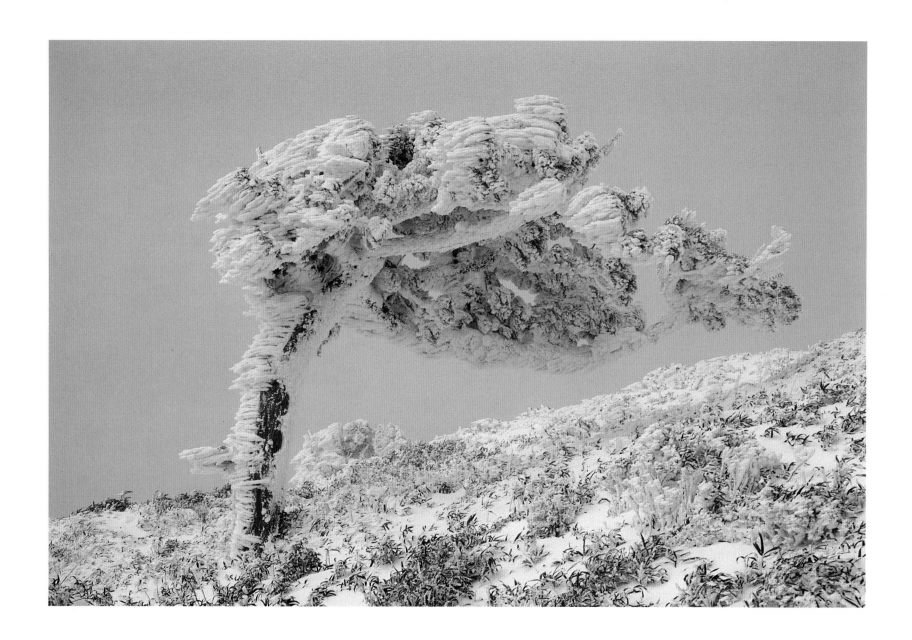

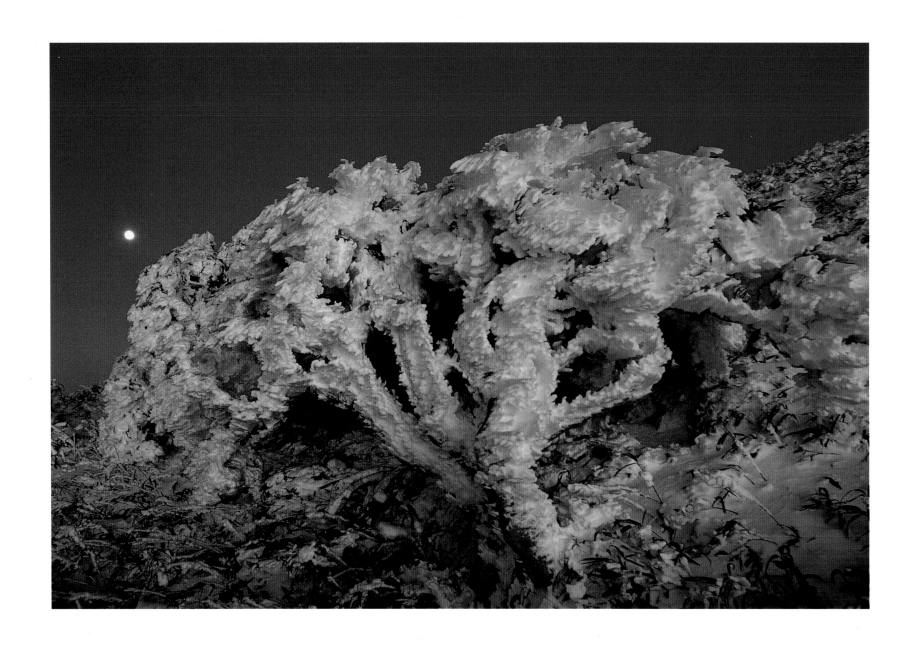

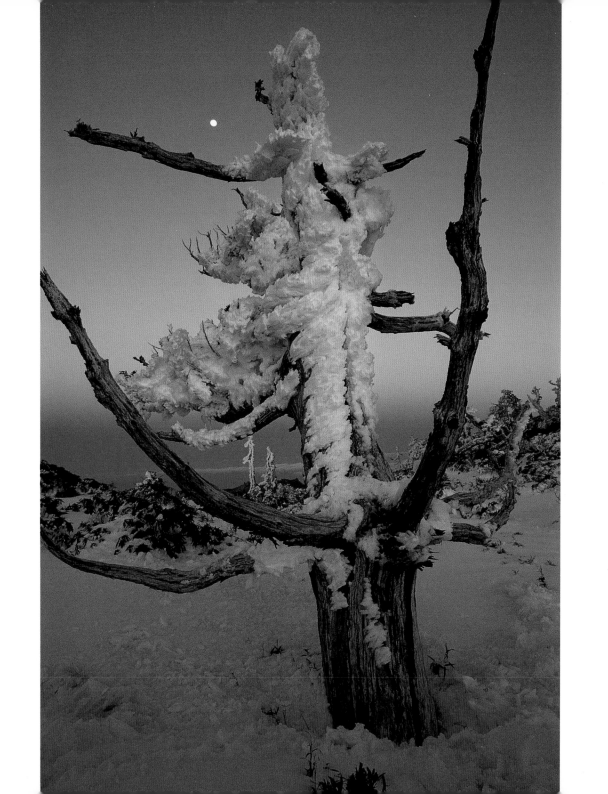

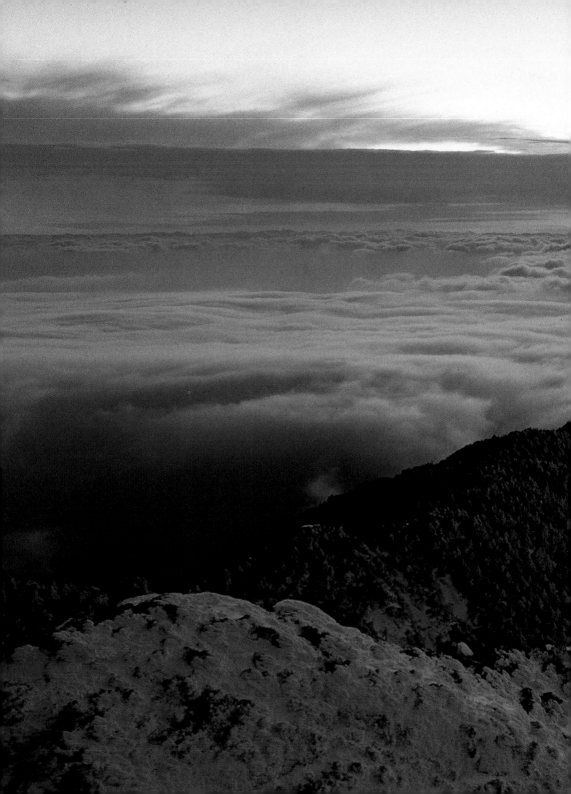

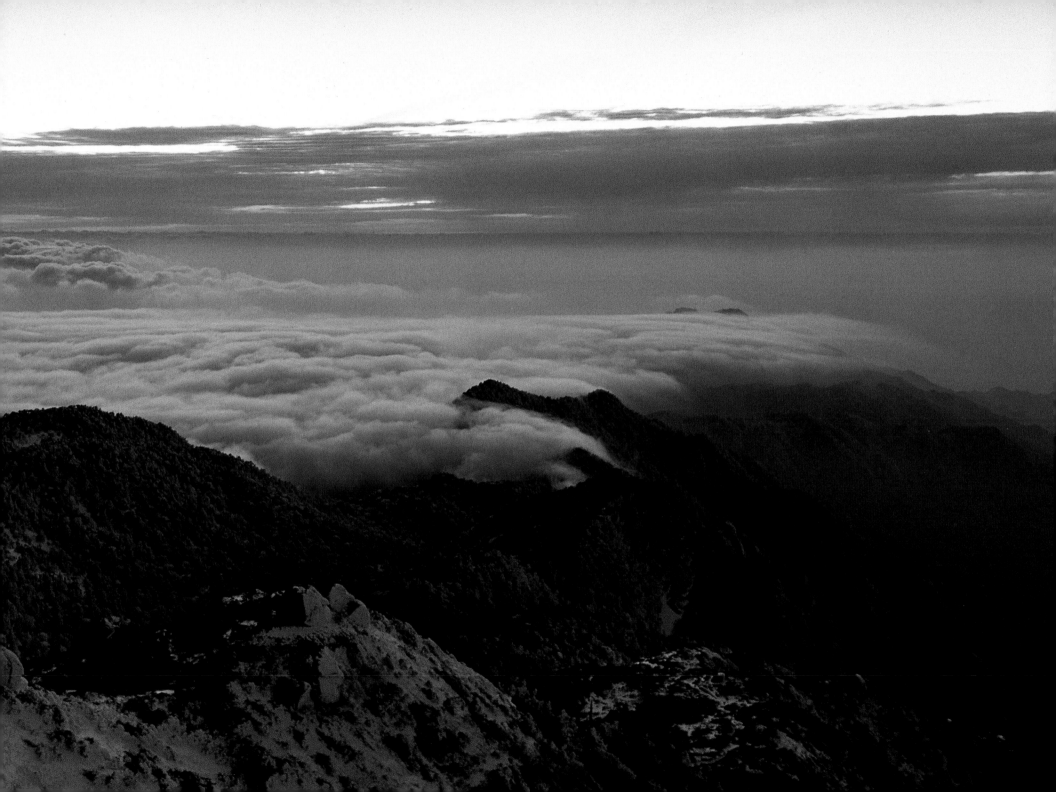

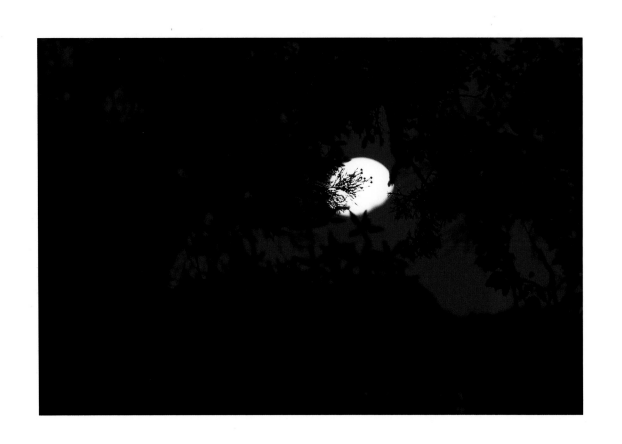

Delicate,
 Subtle,
 Profound.

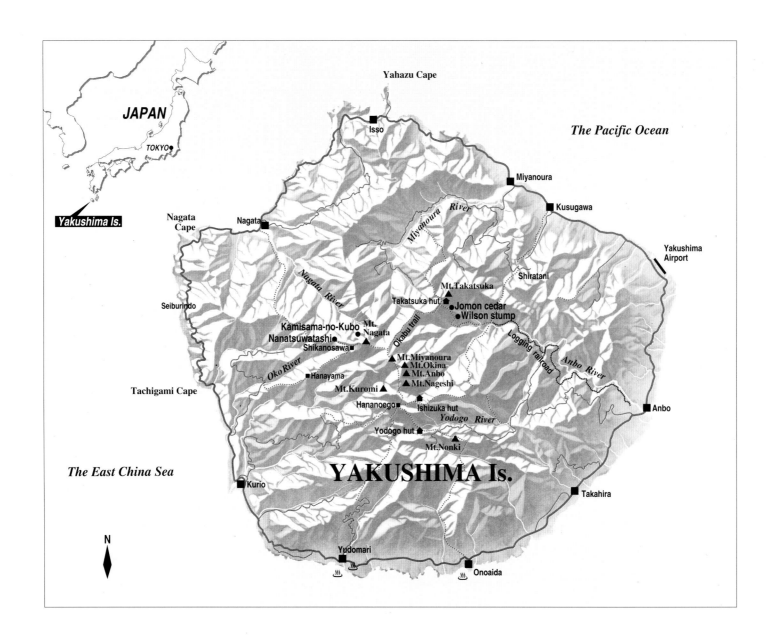

JAPAN

The Pacific Ocean

TOKYO

Yakushima Is.

Yahazu Cape

Isso

Miyanoura

Kusugawa

Nagata
Cape

Nagata

Miyanoura River

Yakushima
Airport

Seiburindo

Nagata River

Shiratani

Mt.Takatsuka

Takatsuka hut

Jomon cedar

Wilson stump

Kamisama-no-Kubo

Mt.
Nagata

Nanatsuwatashi

Shikanosawa

Okabu trail

Logging railroad

Anbo River

Oko River

Mt.Miyanoura

Mt.Okina

Mt.Anbo

Hanayama

Mt.Nageshi

Tachigami Cape

Mt.Kuromi

Hananoego

Ishizuka hut

Yodogo River

Anbo

Yodogo hut

Mt.Nonki

The East China Sea

YAKUSHIMA Is.

Kurio

Takahira

N

Yudomari

Onoaida

Seeing the Forests and the Trees

Hiroaki Yamashita

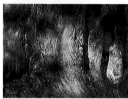

1 From the light of the sun, a new life. Silhouetted on a fallen leaf, a Jomon cedar seedling sprouts.

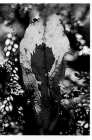

2 A giant tree gives off a gentle warmth. The Jomon cedar in the morning light.

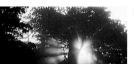

3 It's been a long time since the sun broke through. At Hananoego.

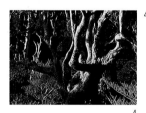

4 On a quiet morning, you can almost hear the *yamaguruma* trees breathing. The eastern slope of Mt. Kuromi.

5 When sunlight strikes, the buds are dazzling. Yakushima rhododendrons on Mt. Anbo.

Again and again in the mountain forests of Yakushima, I have found myself thinking: *How warm trees are.* I feel their gentle warmth when I touch them, and I feel it when I'm merely in their presence. I feel it in them whether they are alive or dead. And this warmth reminds me of my relationship with them.

When I was twenty years old, I loved to gaze at trees in silence. Day after day, I walked through the Yakushima forests without speaking to anyone. And then one day, before a single ancient *yakusugi* cedar, I suddenly realized how warm trees are. The thought just slipped into my mind. Perhaps I sensed the warmth of this tree because it had been alive such an extraordinarily long time—over a thousand years.

Perhaps I sensed it because it stood there so unpretentiously. Or perhaps I sensed it because it was supporting so many other trees. Indeed, rather than a single ancient cedar giant, this tree first appeared to me as a small forest. Gradually, I realized that the "earth" from which the "forest" grew was actually one gigantic trunk, from which numerous epiphytic trees had sprung, creating an enormous expanse of leaves. In fact, this cedar giant still stands today (at Shikanosawa, near the source of the Oko river), and so many *yamaguruma* (*Trochodendron*), rhododendron, and mountain ash grow from it that this cedar looks entirely different depending on the season; in

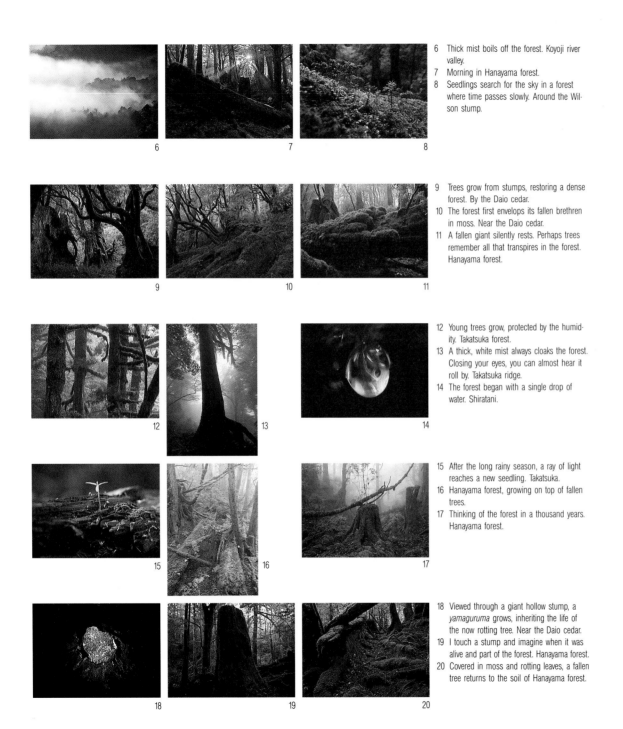

6 Thick mist boils off the forest. Koyoji river valley.
7 Morning in Hanayama forest.
8 Seedlings search for the sky in a forest where time passes slowly. Around the Wilson stump.

9 Trees grow from stumps, restoring a dense forest. By the Daio cedar.
10 The forest first envelops its fallen brethren in moss. Near the Daio cedar.
11 A fallen giant silently rests. Perhaps trees remember all that transpires in the forest. Hanayama forest.

12 Young trees grow, protected by the humidity. Takatsuka forest.
13 A thick, white mist always cloaks the forest. Closing your eyes, you can almost hear it roll by. Takatsuka ridge.
14 The forest began with a single drop of water. Shiratani.

15 After the long rainy season, a ray of light reaches a new seedling. Takatsuka.
16 Hanayama forest, growing on top of fallen trees.
17 Thinking of the forest in a thousand years. Hanayama forest.

18 Viewed through a giant hollow stump, a *yamaguruma* grows, inheriting the life of the now rotting tree. Near the Daio cedar.
19 I touch a stump and imagine when it was alive and part of the forest. Hanayama forest.
20 Covered in moss and rotting leaves, a fallen tree returns to the soil of Hanayama forest.

spring it may have peach-colored blossoms, or in fall it may have leaves turning color.

Yakushima island is nearly sixty miles in circumference, with forests containing an amazing variety of trees (including the forestlike variety described above, in which one tree supports many others). The island's mountains are particularly impressive, and in addition to Mt. Miyanoura (the highest at 6,349 feet), more than forty are over 3,000 feet. They generate mist, attract clouds, and cause rain to fall, so the air in the forests is thick with moisture, and many types of fauna flourish. The trees and the forests exist because of the plentiful rain and the humidity; when you personally experience the rain, it is easy to see why people call it a "life-giving" force. The meaning of the words soaks deep into the soul.

The forests of Yakushima have a dazzling vitality to them. They are crammed with life. But in these forests of life, I always think of the individual trees, standing so calmly. I wonder what it is like for them to exist, and I wonder what causes them to emit the deep and gentle warmth that I sense.

I vividly recall an encounter I once had with a fallen, rotting *yakusugi* when I was walking in Hanayama forest. In the middle of the forest, with its powerful life force, this particular

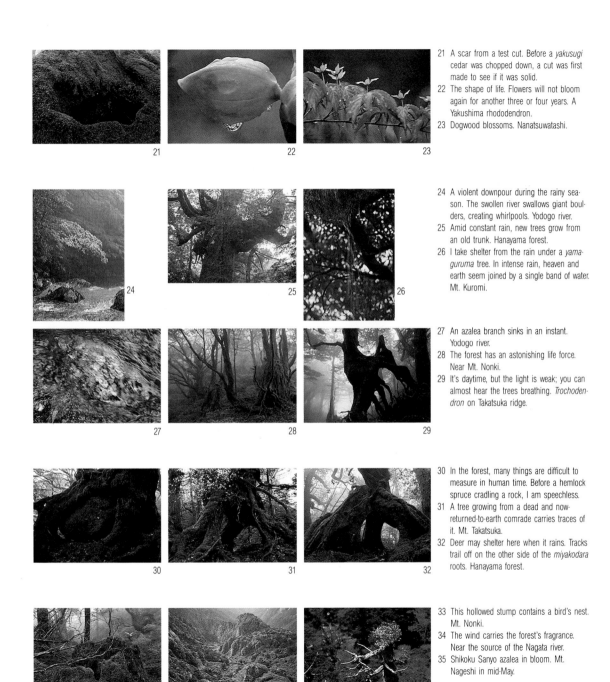

21 A scar from a test cut. Before a *yakusugi* cedar was chopped down, a cut was first made to see if it was solid.
22 The shape of life. Flowers will not bloom again for another three or four years. A Yakushima rhododendron.
23 Dogwood blossoms. Nanatsuwatashi.

24 A violent downpour during the rainy season. The swollen river swallows giant boulders, creating whirlpools. Yodogo river.
25 Amid constant rain, new trees grow from an old trunk. Hanayama forest.
26 I take shelter from the rain under a *yamaguruma* tree. In intense rain, heaven and earth seem joined by a single band of water. Mt. Kuromi.

27 An azalea branch sinks in an instant. Yodogo river.
28 The forest has an astonishing life force. Near Mt. Nonki.
29 It's daytime, but the light is weak; you can almost hear the trees breathing. *Trochodendron* on Takatsuka ridge.

30 In the forest, many things are difficult to measure in human time. Before a hemlock spruce cradling a rock, I am speechless.
31 A tree growing from a dead and now-returned-to-earth comrade carries traces of it. Mt. Takatsuka.
32 Deer may shelter here when it rains. Tracks trail off on the other side of the *miyakodara* roots. Hanayama forest.

33 This hollowed stump contains a bird's nest. Mt. Nonki.
34 The wind carries the forest's fragrance. Near the source of the Nagata river.
35 Shikoku Sanyo azalea in bloom. Mt. Nageshi in mid-May.

cedar made me aware of death—something I had let sink into the recesses of my mind and long ignored.

I sat down on the darkened forest floor and confronted the tree. I knew that no matter how long something lives, it always faces death. And I knew this tree had lived thousands of years, but was now rotting and returning to the earth. Still, I could sense a mysterious warmth emanating from its fallen form. Perhaps, I thought, this was because, as the tree was decomposing under the watchful gaze of its comrades, new trees that would form a new forest were already growing on top of it. The warmth, I realized, resembled that of the earth.

When walking through the forest, you can see the stumps of logged cedar trees, standing like gravestones. Those seven or eight feet tall were logged in the Edo period (A.D. 1600-1867). The famous Wilson stump, with its girth of one hundred feet, is estimated to be three thousand years old and to have been cut down to help build Hokoji temple in 1586.

At first these stumps, standing in silent mourning for over two hundred years, seemed sad. But later I decided they also symbolized the concern that the islanders felt for the cedars. Although the islanders cut down the trees to

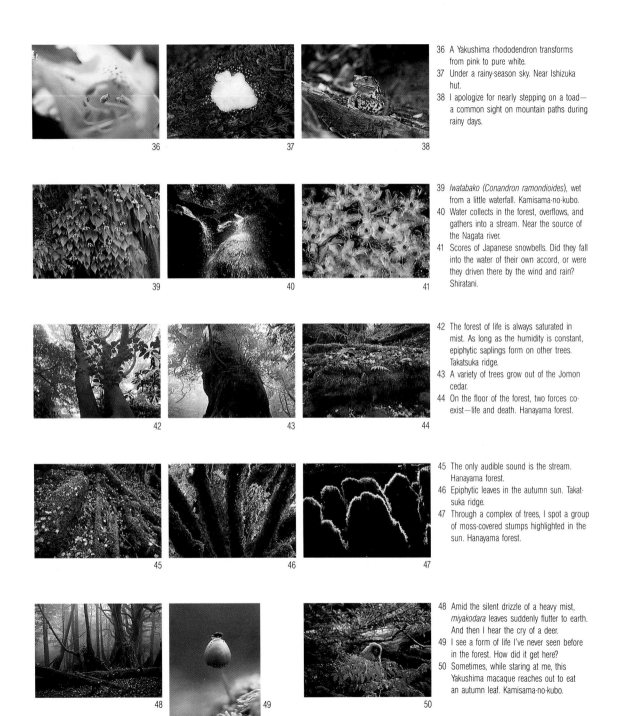

36 A Yakushima rhododendron transforms from pink to pure white.
37 Under a rainy-season sky. Near Ishizuka hut.
38 I apologize for nearly stepping on a toad—a common sight on mountain paths during rainy days.

39 *Iwatabako (Conandron ramondioides)*, wet from a little waterfall. Kamisama-no-kubo.
40 Water collects in the forest, overflows, and gathers into a stream. Near the source of the Nagata river.
41 Scores of Japanese snowbells. Did they fall into the water of their own accord, or were they driven there by the wind and rain? Shiratani.

42 The forest of life is always saturated in mist. As long as the humidity is constant, epiphytic saplings form on other trees. Takatsuka ridge.
43 A variety of trees grow out of the Jomon cedar.
44 On the floor of the forest, two forces co-exist—life and death. Hanayama forest.

45 The only audible sound is the stream. Hanayama forest.
46 Epiphytic leaves in the autumn sun. Takatsuka ridge.
47 Through a complex of trees, I spot a group of moss-covered stumps highlighted in the sun. Hanayama forest.

48 Amid the silent drizzle of a heavy mist, *miyakodara* leaves suddenly flutter to earth. And then I hear the cry of a deer.
49 I see a form of life I've never seen before in the forest. How did it get here?
50 Sometimes, while staring at me, this Yakushima macaque reaches out to eat an autumn leaf. Kamisama-no-kubo.

pay their taxes to the government, they appear to have left the stumps and logs as a type of seedbed for new trees. They left them, in other words, with the forest of a thousand years in the future in mind.

Cutting down a tree that has lived hundreds or thousands of years is like cutting down oneself. I'm certain that in the old days when people performed test cuts on trees to see if they were solid, they also realized that they were being tested by the trees. I suspect, furthermore, that as they cut the trees they were also learning from the trees that the forest is a giant form of life, a collection of many individual forms of life. And I suspect they were also infused with their warmth.

Today the forest is filled with trees that have grown on top of *yakusugi* cedar stumps and logs. These include *yamaguruma, yakusugi, miyakodara* (*Kalopanax pictus var. lutchuensis*), *himeshara* (*Stewartia monadelphi*), and many other large trees. And in their shapes are traces of the ancient stumps and trees from which they grew.

The average annual rainfall high in the mountains of Yakushima is nearly four hundred inches. The forest supports everything from large mammals such as deer and monkeys to the microscopic organisms that return dead wood and fallen leaves to the earth. All these life forms are linked together in a complex fashion, creating a veritable universe within the forest,

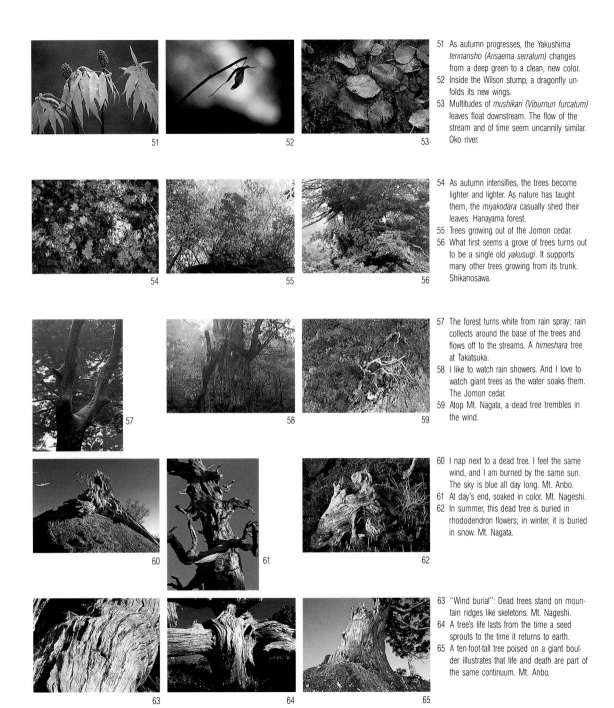

51 As autumn progresses, the Yakushima *tennansho* (*Arisaema serratum*) changes from a deep green to a clean, new color.

52 Inside the Wilson stump, a dragonfly unfolds its new wings.

53 Multitudes of *mushikari* (*Viburnun furcatum*) leaves float downstream. The flow of the stream and of time seem uncannily similar. Oko river.

54 As autumn intensifies, the trees become lighter and lighter. As nature has taught them, the *miyakodara* casually shed their leaves. Hanayama forest.

55 Trees growing out of the Jomon cedar.

56 What first seems a grove of trees turns out to be a single old *yakusugi*. It supports many other trees growing from its trunk. Shikanosawa.

57 The forest turns white from rain spray; rain collects around the base of the trees and flows off to the streams. A *himeshara* tree at Takatsuka.

58 I like to watch rain showers. And I love to watch giant trees as the water soaks them. The Jomon cedar.

59 Atop Mt. Nagata, a dead tree trembles in the wind.

60 I nap next to a dead tree. I feel the same wind, and I am burned by the same sun. The sky is blue all day long. Mt. Anbo.

61 At day's end, soaked in color. Mt. Nageshi.

62 In summer, this dead tree is buried in rhododendron flowers; in winter, it is buried in snow. Mt. Nagata.

63 "Wind burial": Dead trees stand on mountain ridges like skeletons. Mt. Nageshi.

64 A tree's life lasts from the time a seed sprouts to the time it returns to earth.

65 A ten-foot-tall tree poised on a giant boulder illustrates that life and death are part of the same continuum. Mt. Anbo.

but each form seems to be aware of itself. When I realized this, it made me wonder what I represented in the forest.

Once, in early November, I was walking down Okabu trail. Autumn was in full swing, and leaves dyed in the season's colors glistened from a light rain. I stopped to rest for a while under the giant Daio cedar, and the rain grew more intense. Soon both the tree and I were soaked. Huge drops of water started to fall on me from high above, and when they hit my rain gear I could feel the shock of the impact; something about the sight of water flowing down the trunk of the tree also made me imagine that blood was flowing through the tree. The Daio cedar is around three thousand years old and partly hollow inside, so I took shelter in it as the rain continued. I felt as though this tree, which embraces both life and death, was warming me with its body. With a sigh of appreciation, I finally understood why people in the old days never cut down hollow trees like the Daio.

I arrived at the famous Jomon cedar late in the afternoon of the same day. The Jomon has survived since ancient times and is said to be around 7,200 years old. It was still raining when I encountered it, and I again had a strong sense not so much of the power of its years but of its warmth. Numerous epiphytic trees, including mountain ash and *tsuribana* (*Euonymus oxyphullus*),

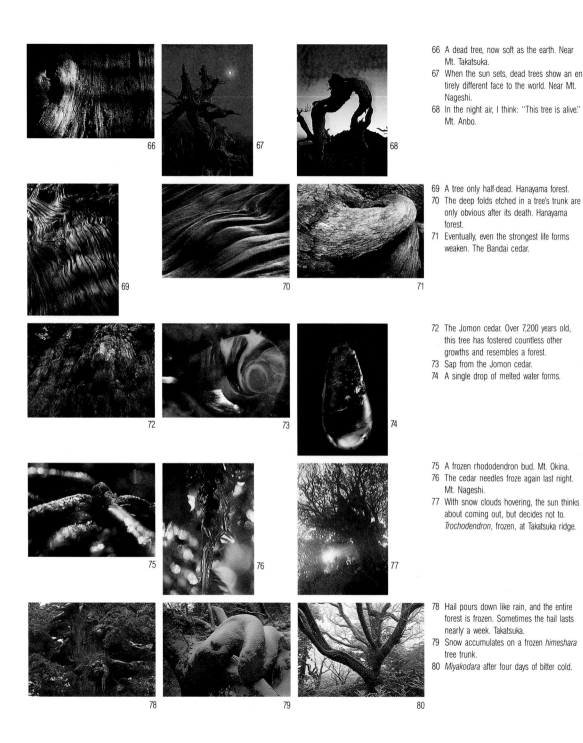

66 A dead tree, now soft as the earth. Near Mt. Takatsuka.
67 When the sun sets, dead trees show an entirely different face to the world. Near Mt. Nageshi.
68 In the night air, I think: "This tree is alive." Mt. Anbo.

69 A tree only half-dead. Hanayama forest.
70 The deep folds etched in a tree's trunk are only obvious after its death. Hanayama forest.
71 Eventually, even the strongest life forms weaken. The Bandai cedar.

72 The Jomon cedar. Over 7,200 years old, this tree has fostered countless other growths and resembles a forest.
73 Sap from the Jomon cedar.
74 A single drop of melted water forms.

75 A frozen rhododendron bud. Mt. Okina.
76 The cedar needles froze again last night. Mt. Nageshi.
77 With snow clouds hovering, the sun thinks about coming out, but decides not to. *Trochodendron*, frozen, at Takatsuka ridge.

78 Hail pours down like rain, and the entire forest is frozen. Sometimes the hail lasts nearly a week. Takatsuka.
79 Snow accumulates on a frozen *himeshara* tree trunk.
80 *Miyakodara* after four days of bitter cold.

were growing from its trunk, their leaves shining in the rain or, having fallen off, lying scattered about the Jomon's base. How many times, I wondered, had the ancient Jomon cedar been rained upon? It had witnessed the deaths of countless other trees in the woods around it. It had seen tree after tree emerge from its own trunk in the rain and die in the rain. Yet the Jomon was still standing. If the earth is where dead trees return to, then the Jomon cedar is surely earth itself.

The climate on Yakushima is generally mild, but for the trees on the mountain ridges it is harsh. They stand exposed, year after year, lashed by rain and buffeted by strong winds, and in the winter they face cold and snow. Yet despite this, you can see *yakusugi* cedar and rhododendron surviving on steep slopes and rocky crags high in the mountains. For every tree that has survived, many more have not.

While walking along glens and ridges, sometimes parting Yakushima bamboo grass taller than a human, I saw rhododendron and juniper growing, almost crawling, on the ground. (At first I was unable to tell if they were dead or alive.) Then, climbing higher, still parting the grass, I suddenly came across a stump. It was thirteen feet high and three feet in diameter, yet this gave no hint of when the tree might have

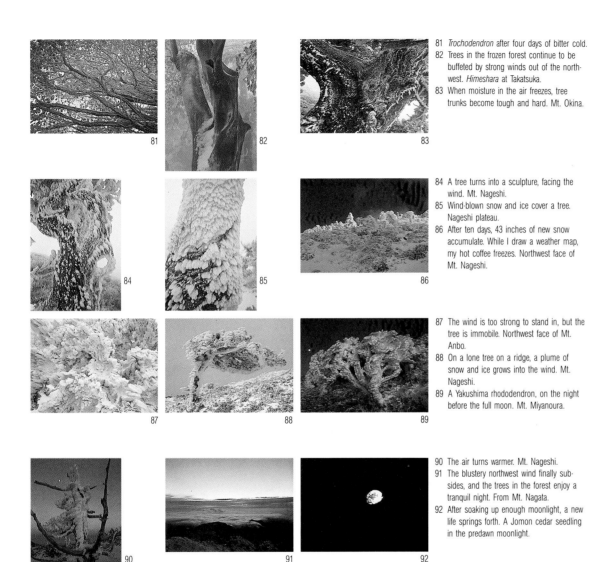

81 *Trochodendron* after four days of bitter cold.
82 Trees in the frozen forest continue to be buffeted by strong winds out of the northwest. *Himeshara* at Takatsuka.
83 When moisture in the air freezes, tree trunks become tough and hard. Mt. Okina.

84 A tree turns into a sculpture, facing the wind. Mt. Nageshi.
85 Wind-blown snow and ice cover a tree. Nageshi plateau.
86 After ten days, 43 inches of new snow accumulate. While I draw a weather map, my hot coffee freezes. Northwest face of Mt. Nageshi.

87 The wind is too strong to stand in, but the tree is immobile. Northwest face of Mt. Anbo.
88 On a lone tree on a ridge, a plume of snow and ice grows into the wind. Mt. Nageshi.
89 A Yakushima rhododendron, on the night before the full moon. Mt. Miyanoura.

90 The air turns warmer. Mt. Nageshi.
91 The blustery northwest wind finally subsides, and the trees in the forest enjoy a tranquil night. From Mt. Nagata.
92 After soaking up enough moonlight, a new life springs forth. A Jomon cedar seedling in the predawn moonlight.

died, for in the light the stump had a silver glow. It was displaying itself in the bright sunlight, I decided, proud of having lived so long, with such determination.

Standing next to this stump, I imagined that I knew how it felt. Trees live by sinking their roots into the earth, so they may know instinctively that death is merely a return to the earth. And they also may know that life is sacred precisely because there is death. Perhaps the deep warmth I feel from trees results because they live in such close proximity to death. I wondered how long it would be before this ancient tree would completely return to the earth. It might take almost as many years to decompose as it had once lived. But I knew that eventually a new tree would inherit its spirit and grow tall and strong from where it had once stood.

Every tree in the forests of Yakushima fills me with awe, warms me, and gives me energy. I can never see enough of the trees that form such rich forests. Like a seed that quietly absorbs the moonlight and later sprouts, something very real has taken root in my soul.

Equipment Data: CANON F-1
FD20mm F2.8/FD24mm F2/FD35mm F2/
FD50mm F1.4/MACRO FD50mm F3.5/FD85mm F1.8/
MACRO FD100mm F4/FD200mm F2.8/
MACRO FD200mm F4/REFLEX500mm F8

© HIROMI NOGUCHI

Hiroaki Yamashita
Of those who have photographed
Yakushima's natural environment,
Yamashita is by far known the best for both
the quality and variety of his work on this island.
Yamashita was born in 1955 in Kagoshima,
the area on the mainland nearest to Yakushima.
After graduating from college in Tokyo,
he spent more than half of each year for
thirteen years photographing Yakushima,
possessed by the island's beauty.
He is one of the few men who has walked
and climbed all around the island,
especially among the cedars.
Many think Yamashita is among the few
who know the real state of the cedar forests.
His photographs have appeared in various
magazines and books in Japan.

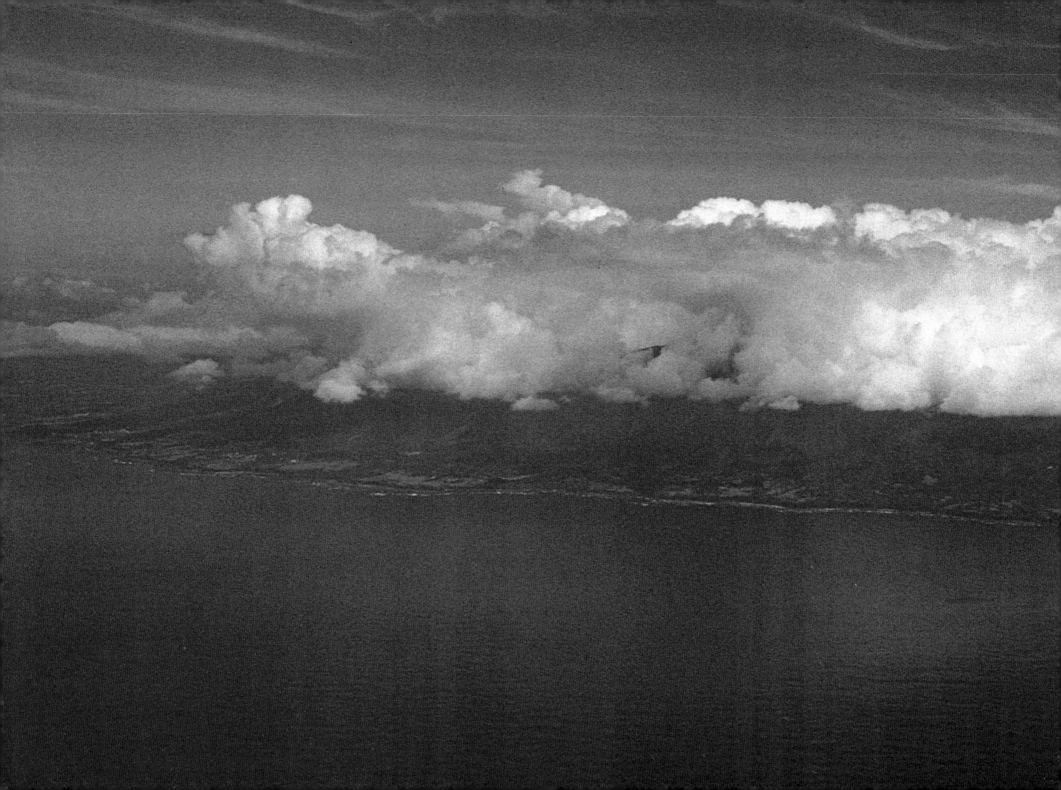